THE PLATINUM PRINT

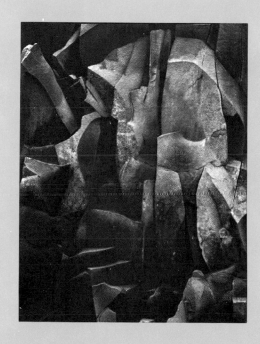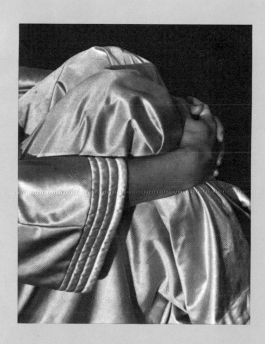

JOHN HAFEY & TOM SHILLEA

Duotones: Zenon Elyjiw
Book Design: Sasha Trouslot, John Hafey
Paper: S. D. Warren
Type: Pontiac

Hafey, John, 1946-
 The platinum print.

 Bibliography: p. 111
 1. Photography—Printing processes—Platinotype.
I. Shillea, Tom, 1947- joint author.
II. Title.
TR420.H33 772'.3 79-55710
ISBN 0-89938-000-X

To John, Kathryn, and Suzi
Sylvester, Genevieve, Lucy, and Jacqueline.

ACKNOWLEDGEMENTS

We would like to express our deep appreciation to all the photographers who so graciously loaned their work for the exhibition and this publication. We would like to thank Charles Arnold, Owen Butler, Dr. Russell Kraus, Daniel Levine, Elliott Rubenstein, and Dr. Richard Zakia of Rochester Institute of Technology for their support, guidance and encouragement. We were given invaluable assistance in our research by Marianne Margolis, Marilyn McCray and Martha Jenks of the George Eastman House, Alan and Devara Goodman of Elegant Images, Gail Freckleton of the Eastman Kodak Company, and Susan Barger at Penn State University. But without the full support of Mr. Herbert Phillips, Director of the Graphic Arts Research Center, his staff and particularly Sasha Trouslot, Zenon Elyjiw, and Richard McAllen, this project would still be just an idea.

INTRODUCTION

This book is about photography, and our involvement with one of the older photographic processes, the platinotype. It is our intention to make an aesthetic statement, documenting the origins, development, and contemporary use of the platinotype. As photographers, our initial interest in the platinotype evolved from an exploration into a variety of older photographic processes, Van Dyke Brown, Cyanotype, and Gum Bichromate. When we became dissatisfied with the results obtained from these processes, we turned our attention to the platinum printing process.

We were aware that many of the master photographers of the late nineteenth and early twentieth century had used the platinotype to create images of exceptional beauty. These photographers found the platinotype to be one of the premier printing processes. We were attracted by those same inherent qualities. The platinotype has a long, rich and subtle range of tones from quiet blacks to delicate middle grays and soft highlights. The image color can be varied from neutral black to warm brown by the addition of lead oxalate, gold chloride, or mercuric chloride to the sensitizing solution. Image color is also somewhat dependent upon the type of developer used. The contrast of the sensitizing solution can be mixed to complement a particular negative, and contrast can also be controlled in the development stage. Localized development is also possible with the use of glycerine. As the paper is hand prepared, the photographer has the opportunity to coat the platinum emulsion on a wide variety of paper surfaces. The platinotype possesses the potential for manipulation and combination with other media. It is as permanent as the material on which it is printed.

As our interest in the platinotype grew, we sought additional information in the original formulae and literature. We found in conducting this research that attempts had been made to document the history of the platinotype, particularly by Captain Abney, but the history of the platinotype was fragmentary and scattered through a variety of source material. The fragmentary nature of the information relating to the platinotype led us to search out and document the scientific, commercial, and aesthetic development of the platinotype for our own use. We found that the scientific experiments conducted using platinum as part of a light sensitive imaging system made possible the development of commercial and hand prepared platinum paper. The availability of platinum paper to "amateur" photographers allowed them to pursue a new aesthetic, the beginnings of "straight" photography. The wide use of the platinotype in the early part of this century played an important part in the development of photography as an art form.

More recently, in the past fifteen years, with a general increase in the popularity and awareness of photography, there has been a renewed interest in the older photographic processes, Daguerreotype, Ambrotype, Albumen, along with a general increase in the use of other non-silver processes. As part of this general trend, the number of people making platinum prints has also increased. As we worked more with the platinum process, we began to encounter these contemporary photographers and their work. With the cooperation of the photography gallery at Rochester Institute of Technology, we organized an exhibition of platinum photographs in February of 1979. Two images of each artist represented in the exhibition are reproduced in this volume. Although we realize that there are other photographers working in platinum that are not represented, we feel that the images we have selected are indicative of the work being done in platinotype. Many of the images have a close relationship with earlier imagery, while others deal with more contemporary concerns. Unlike silver imagery, the platinotype amplifies depth and surface texture. The platinotype deals not only with the content of the image but with the "skin" of things.

All those photographers who have made platinum prints in the past or who are making them now are indebted to those early scientists who discovered the light sensitivity of certain iron salts, and their relationship to platinum metal. Without their initial work, the development of the platinotype process might never have occurred, and the elegant images of the early part of this century and the photographs in this book might not have been produced.

John Hafey
Tom Shillea
Rochester, New York
1979

THE PLATINUM PRINT

A

HISTORY

Scientific Discovery and Commercial Development

Ferdinand Gehlen was the first person to explore the action and effects of light rays upon platinum and record his experiments. In 1830, he discovered that a solution of platinum chloride when exposed to light, first turned a yellow color, and eventually formed a precipitate of metallic platinum.[1]

In 1831, experiments by the chemist Johann Wolfgang Dobereiner obtained important results. Born in Bavaria in 1780, he practiced pharmacy in Karlsruhe, and devoted himself to the study of the natural sciences, particularly chemistry. In 1810, he was given the position of professor of chemistry and pharmacy at the University of Jena, where he taught until his death in 1849.[2] He observed that platinum metal was only slightly affected by the action of light, and concluded that some substance would have to be added to the pure platinum metal to increase its sensitivity to light. He experimented combining sodium platinum chloride with alcohol and potassium hydroxide, and also with a combination of platinum salts and tincture of iodine. Dobereiner's work is important, however, because of his choice of a substance to combine with the platinum metal to make it more light sensitive. He chose ferric oxalate. When he combined ferric oxalate with platinum chloride, and exposed the solution to light, he observed that a precipitate of platinum metal was formed.[3] This combination of potassium chloroplatinite and ferric oxalate is still the basis of the platinotype process in use today.

A year later in 1832, Sir John Herschel announced to the British Association at Oxford, that when a solution of platinum, neutralized by the addition of hydrochloric and nitric acids and then

mixed with a solution of sodium hydroxide, was placed in the dark, no reaction occurred. However, when the solution was placed in the sunlight, a white precipitate was formed. Herschel also explored the effects that different wavelengths of light had upon the platinum solution. He exposed the platinum solution to sunlight that was passed through various colored liquids which acted as filters. Herschel discovered that the light sensitivity was confined to the violet end of the spectrum. He stated in his findings, "sulphuric tincture of rose leaves protected the solution entirely," as did yellow fluids such as potassium dichromate.[4]

Robert Hunt, a contemporary of Herschel, was at the same time conducting his own experiments involving the action of light on various chemical compounds. In his book, *A Popular Treatise on the Art of Photography* (1841), he recounts some experiments using platinum chloride on paper coated with silver iodide. However, he was unsuccessful in obtaining any prints from these experiments.[5] In *Researches on Light,* (1844), he records his experiments and appears to be the first person to employ platinum in making photographic prints. Hunt mixed platinum chloride with a boiling solution of potassium cyanate. This solution was used to coat paper and a faint image was produced after a prolonged exposure. Hunt then placed the paper in a mercury solution and a beautiful though delicate positive image resulted. An unsuccessful attempt was made to make the image permanent by washing the print in a dilute solution of sodium carbonate.[6]

Hunt tried other chemicals in combination with platinum. His results were never predictable; either a negative or a positive image might be the result. He also tried combining platinum with silver nitrate, resulting in a good negative image and at other times resulting in a positive picture with a deep lilac tint. Although he tried several means of fixing his prints, including potassium iodide, they all faded after several months.

In the 1854 edition of his *Researches on Light,* Hunt relates a curious occurrence. "Nearly all the Platinotypes slowly fade in the dark. This was written in 1844. I have now (1854) in my possession one of these pictures which faded at first but gradually restored itself, until now after ten years, it is quite perfect and permanent, transformed, however, from a negative to a positive image."[7]

During this time, Hunt corresponded with and followed the work of Sir John Herschel. Herschel called Hunt's attention to the iodides and bromides of platinum which Herschel found capable of forming an image, but which also faded in time. In his own writing, Hunt mentions Herschel's *Memoir on the Chemical Action of the Rays of the Solar Spectrum.* In that memoir, Herschel mentions an experiment involving potassium chloride and platinum in combination with potassium hydroxide producing a well defined image of the object shading the paper when it was exposed to light. An increase in contrast resulted when the image was washed again in the potassium hydroxide solution.[8] Neither Hunt nor Herschel were able to develop a predictable platinum process.

When a workable platinum printing process could not be developed, and more reliable printing methods such as salted paper prints, albumen printing paper, and eventually gelatin paper were developed and produced commercially, research into the use of platinum as a printing medium ceased. However, the relationship in the family of metals between gold and platinum caused people to explore the possibility of using platinum as a toning agent as they used gold. In this initial work with platinum toning, an image was first formed of another substance, usually silver. The silver metal was then thought to be converted to platinum by toning. In effect, these toning processes did not entirely replace the silver metal with platinum. A portion of the silver crystal was etched away by the platinum toner and the silver metal became gilded with the platinum metal in the toner.

A Frenchman, Monsieur de Carranza is reputed to be the first person to publish a formula for platinum toning in *La Lumiere* in 1856. In the same year C. Poupat published a formula for toning albumenized paper utilizing sodium chloroplatinite.[9] A year later, Baldus published a formula in *Photographic Notes* describing the use of platinum chloride instead of gold to tone prints produced by Blanquart-Evrards albumen printing process. Watts commented that prints toned by this method do not fade, although continually exposed to light for years. In 1859, Gwenthlian reported in *Photographic News* some experiments with platinum toning, noting that alkaline solutions produced warm brown tones while acidic solutions rendered cool bluish tones.[10] C. J. Burnett also derived several formulae for platinum toning baths. He used platinic nitrate or sulfate. In an article published in the *British Journal of Photography* in 1859, he recommended the use of sodium chloroplatinite, a salt closely analogous to the one introduced by William Willis in 1873. Burnett was the first person to exhibit prints illustrating his experiments using platinum in photographic

printing. This exhibition took place at the British Association meeting in 1859.[11] Lyonel Clark also described a consistent platinum toning process in 1859. He displayed examples of his work at a meeting of the Camera Club.

In France, also in that year, the Duc de Luynes described a gold and platinum printing process to the French Photographic Society. He stated that his experiments were suggested by Louis Poitevin. In conducting his experiments, the Duc de Luynes rediscovered Herschel's Chrysotype process which used ferric ammonium citrate as the light sensitive substance. He found, as had Herschel, that the exposed portions of the iron salts would reduce gold salts to a metal. He added gold chloride to ferric ammonium citrate and obtained a brown positive image.[12]

By the late 1850's, scientific research into the use of platinum in photography had diminished considerably. Scientists who had been investigating the nature of photography moved on to other areas. Silver was found to be more light sensitive than platinum, and therefore more suited to forming images. Gold had proved to be more reliable as a toning agent. It was not until the 1870's and 1880's when methods were developed to make light sensitive platinum emulsions using ferric salts and then chemically convert the iron image to one of platinum that platinum found a useful place in photography. Eventually, patented, commercially produced platinum paper became the most popular printing medium in the late nineteenth and early twentieth century.

The first patent for a platinotype process was granted to William Willis in 1873 (British Patent No. 2011, June 8, 1873), entitled "Perfection in the Photomechanical Process."[13] Willis, born in 1841, was the elder son of a well known engraver of landscapes, and worked as a practical engineer in Birmingham, England after completing his education. This experience proved valuable to him in later years, enabling him to solve the mechanical problems involved in the commercial production of platinum paper. Willis was employed by the Birmingham Midland Banks,[14] but eventually joined the employ of his father who had invented an aniline printing process for the reproduction of technical designs and drawings.[15]

Recognizing the impermanence of silver images, Willis decided to find a more stable metal to use in making photographic images. Willis chose platinum for his experiments. Willis recounted his experiments and invention in a paper delivered to the Camera Club Conference in 1888. He stated that while experimenting with the reduction of metal by means of ferrous salts, particularly ferric oxalate, he was struck with the obstinate way in which the platinum salt was not reduced. He concluded that some chemical could be found that would aid in this reduction. A note from a French chemist led him to try potassium oxalate. This experiment proved successful.[16]

During the next seven years, Willis obtained two more platinotype patents. In 1878, he was granted a patent[17] whose main advantage over the initial process was the elimination of the silver salts and the necessary hyposulfite bath. His third patent,[18] received in 1880, is substantially what became the classic platinotype process. Known as the hot-bath method, because of the developer temperature, this process consisted of applying the platinum salt to the paper and omitting it from the developer. The lead and silver salts were also omitted from the sensitizing solution. The entire procedure was thus greatly simplified and the process became more controllable.[19] In 1882, Willis proposed a method of platinum intensification. By treating a silver image with ferric oxalate, he changed that image into one of silver oxalate. Then, he poured potassium chloroplatinite over the image changing it to one of silver chloroplatinite. Using heated ferric oxalate as a developer, he reduced the silver and platinum salts to their metallic state. The platinum, however, rendered the gelatin insoluble and impermeable, caused irregularities, and therefore the process was quickly dropped.[20] In 1881, Willis received the Progress Medal of the London Photographic Society, and in 1885, the Gold Medal of the International Invention Exhibition.[21] Willis was the first person to produce prints in metallic platinum employing platinum salts in combination with light sensitive ferric salts.

Although Willis produced beautiful photographs with the platinum printing method that he invented, a reliable process for the individual preparation of platinum paper had not been invented. A dissertation, by two Austrian Army officers, Giuseppe Pizzighelli and Arthur Baron V. Hubl, published in 1882 and awarded a prize by the Vienna Photographic Society, made the platinotype process available to the general public. Pizzighelli and Hubl initially followed Willis' method for the preparation of platinum paper utilizing ferric oxalate and potassium chloroplatinite, and then developing it in a potassium oxalate solution. In October of 1887, however, Captain Pizzighelli patented a new and different platinotype process. He found that double salts of ferric oxalate were serviceable in the preparation of platinum paper and that addi-

tion of sodium oxalate to the sensitizing solution eliminated the necessity of liquid development. With the developer incorporated into the sensitizing solution, the platinum salt was reduced and the platinum metal image formed during exposure. The image was then soaked in a mild hydrochloric acid bath to etch away the iron, and then briefly washed in water to remove any acid. This was the first printing out platinum process, and it was marketed under the name "Dr. Jacoby's Platinum Printing Out Paper."[22]

Not to be outdone, William Willis obtained two more patents for the platinotype processes. In 1888, he developed and patented the cold-bath process. The platinum was removed from the sensitizing solution and placed in the developer. This procedure produced rich brown blacks rather than the yellow sepia browns of the previous processes. The increased amount of platinum required by this process and the resultant increase in expense, and the uncertainty of the paper preparation caused this method to be abandoned. In 1892, Willis began to manufacture platinum paper under a new patent which was for the cold-development process. Not to be confused with the cold-bath process in which the platinum was placed in the developer, the cold-development process required that the platinum be placed in the sensitizing solution, and the paper then coated with it. Since the development was done at room temperature, additives such as glycerine could be used for localized development and manipulation.[23]

By 1894, the platinotype had gained such popularity that 175 of 382 prints in the Photographic Society exhibition were platinotypes as compared with only 15 of 373 in the 1880 exhibition. The popularity of the platinotype was also reflected in the number of companies that began to produce platinum paper and the number of instruction manuals that were published to aid amateur photographers in producing platinotypes. After William Willis founded the Platinotype Company in London in 1880 to manufacture platinum paper, other companies began to manufacture platinum paper in various tones and surfaces. Platinum paper produced by the Platinotype Company was distributed in the United States by the firm of Willis and Clements of Philadelphia. W. J. Warren in his instruction manual states that platinum paper was available from Willis and Clements in three surfaces: AA, a smooth surface; BB, a semi-matte surface; and CC, a roughly textured surface. Warren also quoted prices for platinum paper in 1899. He stated that one dozen sheets of 4 x 5 platinum paper cost 45 cents; one dozen sheets of 8 x 10 paper cost one dollar and seventy cents; and one dozen sheets of 11 x 14 paper cost three dollars and forty cents.[24]

Although Willis and Clements dominated the sale of platinum paper with sales of 273,715 dollars in 1906, Eastman Kodak brought out a line of platinum paper in that year which had sales of 35,639 dollars.[25] Prior to 1906, Eastman Kodak had tried without success to develop a platinum paper. The 1901 Eastman price list mentioned "Eastman's Platinum Paper" in rough and smooth surfaces, but the product may not have been marketed. The American Aristotype Company of Jamestown, New York, which later became part of the Eastman Kodak Company, produced platinum paper in smooth and rough surfaces and in three weights; medium, heavy and extra heavy. Although Eastman Kodak literature mentions the production of "Eastman's Water Developed Platinum Paper" from 1901 to 1910, by 1906 the Eastman Kodak Company had not been successful in developing and marketing a platinum paper. In order to increase their share of the platinum paper market, Eastman Kodak attempted to purchase the firm of Willis and Clements. The Philadelphia firm, however, was not interested in becoming part of the Eastman Company. Eastman Kodak finally purchased the firm of Joseph Di Nunzio in Boston. Di Nunzio had been an employee of American Aristotype. He developed a platinum paper and marketed it under the name "Angelo." Eastman Kodak purchased the Di Nunzio firm in 1906 and added "Angelo" platinum paper to its line. By 1910, sales of "Angelo" paper had reached 111,533 dollars.[26] In July of 1909, Eastman Kodak brought out "Etching Black Platinum Paper" and in October of 1910, "Etching Sepia Platinum Paper" was introduced. With the outbreak of World War I, platinum became more difficult to obtain and increasingly expensive. The demand for platinum paper also began to diminish to a point where it was unprofitable to produce commercially. On June 1, 1916, Eastman Kodak ceased manufacture of all platinum paper. Platinum paper, however, was commercially produced in England by the Platinotype Company until the late 1930's.

Over thirty years elapsed between the first platinotype patent granted to William Willis in 1873 and the period after the turn of the century when the platinotype reached the zenith of its popularity. The time necessary for the technical development and commercial perfection of platinum paper accounted for only a small portion of the period between its introduction and its acceptance as one of the premier photographic printing processes.

6

Aesthetic Evolution

A new aesthetic climate and artistic concern was evolving in the 1880's and 1890's. Some photographers began to react against Victorian pictorialism, manipulative and combination printing, and the imitation of painting. These new "amateur" photographers wanted to elevate photography to an art on a level with painting and sculpture. Their images relied on the strength of their own vision; and they emphasized those qualities which were uniquely photographic.

To fully understand the evolution of this new aesthetic and the role that the platinotype played in its development, one must be aware that many early photographers were painters who for various reasons took up photography. Their approach to photography was based upon the technical and aesthetic concerns of their original medium. The result was the imitation of painting through photography. The variety of effects and techniques used by these early photographers can be categorized as pictorial photography. The common theme in all their work was an insistence on the imitation of painting through manual manipulation of the straight print. Their techniques included retouching the negative and actually drawing or painting on the print. The most popular pictorial technique was combination printing. This method allowed the photographer to create his image of elements from two or more different negatives, in other words "piecing together several negatives to make one masterpiece."[28] The photographs created as a result of these pictorial effects flattered and satisfied the Victorian taste of the art conscious public.[29] Photography became an extension of the sentimental and conservative aesthetics of established academic painting.

The two photographers most responsible for establishing the pictorial effects were Henry Peach Robinson and Oscar J. Rejlander. Rejlander was a Swedish painter, turned photographer, living and working in England. In 1857, he exhibited his famous moral allegory, titled "The Two Ways of Live." It is one photograph made up of 33 different negatives of the same two or three models photographed in different poses.[30] This photograph became the quintessence of combination printing.

But the most influential personality of pictorial photography was Henry Peach Robinson. He began his career as a painter. His painting was greatly admired and he exhibited at the Royal Academy in London before he was 21 years old. His influence on photography was strongly felt through his prolific photographic and literary output. In 1856, he displayed his most famous combination print titled "Fading Away." It caused a storm of controversy because its subject, a young girl dying, was considered too painful to be represented photographically.[31]

Robinson's success was so meteoric that he decided to establish rules for what he considered "High Art" photography. In 1869, he published his famous book titled *Pictorial Effect in Photography; Being Hints On Composition And Chuariscuro For Photographers To Which Is Added A Chapter On Combination Printing.* The book contained formalized instruction in the making of art photographs based on academic rules of design and composition. He illustrated these theories with simple drawings and actual albumen prints of his own work. He advocated the proper manner to get the best out of a sitter and described his own photographing technique which was strongly theatrical.[32] "As the Science of Photography has its formulae," wrote Robinson, "so has the art of picture making, in what ever material, its rules."[33] He actively encouraged photographers to imitate painting. His advice to the novice was . . . "to use any dodge, trick or conjuration of any kind in his work . . . It is his imperative duty to avoid the mean, the ugly, the base, and to aim to elevate his subject, to avoid awkward forms, and to correct the unpicturesque . . . A great deal can be done and very beautiful pictures made, by a mixture of the real and artificial in a picture."[34] Similar to academic painting, the pictorial photographers soon established a group of individuals whose work appeared and reappeared in the crowded Photographic Salons of the time. These groups were usually made up of independently wealthy or professional studio photographers. Their social connections and financial position often meant more than the quality and originality of their work. Independent workers and thinkers were annually excluded from the Salons.

Although these independent amateur photographers were prohibited from entering the inner circles of the Salons, their numbers and their enthusiasm continued to grow and gain momentum. A new feeling about the essential qualities and power of photography began to take shape, as a reaction against the imitative nature of pictorialism. The amateurs began to organize. Perhaps the first significant step in this direction was the publication by A. Horsley Hinton, in 1884, of *The*

Amateur Photographer magazine. This new movement was seen by its founders as a means of reinstating the creative integrity of photography as a medium of expression. The word amateur was becoming an accolade, a word equal to artistic. Hinton selected the title of his publication to distinguish it from the other photo publications aimed at professionals which concentrated more on technique and manipulation than on visual aesthetics.[35]

The new movement soon began to establish its own principles of picture making. Foremost was a belief in the inherent and beautiful qualities of the straight, unmanipulated print. As the pictorialists had their champion in Robinson, the new movement had its own spokesman. He was Peter Henry Emerson, an American physician living in England. Emerson firmly believed in the absolute importance of the straight, or as he called it, the pure approach to photography. He believed that marring the photograph in any form, from flattering retouching to imitations of paintings, drawings or other handiwork was an abomination.[36]

Emerson, and his growing number of followers, believed that straight photography was the most severe challenge in all the arts. "It is you, facing yourself. You are the lens, the camera and the film. You can't hide behind the sensuous appeals of the other arts; the brushstroke, the impasto, the glaze, the tyranny over time in music, the weight, thrust and soar of architecture and sculpture. If these are felt in your photographs they are reflections of what you feel."[37]

In 1883 Emerson joined the Photographic Society of Britain. He immediately began to protest against the overcrowded hanging of the photographs in the Society's annual salons. He felt this crowded system made it im-

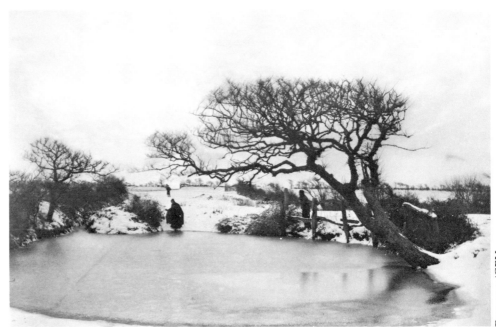

itation of bad painting, — the sentimental, the banal, the anecdotal and the gaudy. He personally vowed to clean up the mess and let people see how beautiful Nature could be as revealed through the straight, unmanipulated photographic print.[38]

Emerson used his own words and photographs to persuade his audience. He soon established a theory of art based upon scientific principles. He believed that the responsibility of the artist was the representation of the effects of nature on the eye. Emerson's research into the optical theories of Herman von Helmholtz, expressed in Helmholtz's book *Physiological Optics,* helped Emerson establish his most important ideas.

Helmholtz stated that the accurate rendition of nature was impossible, since the scale of pigment is infinitely less than the scale of light. The conditions of picture making could only be relative. They were an impression. Emerson extended this Helmholtzian idea of "vision as impression" to photography. He believed that the impression must be absolutely faithful to Nature. Nothing must be altered, added or subtracted. Every nuance of light and atmosphere must be faithfully recorded. The painter becomes a type of lens, more or less perfect, through which Nature is transferred to a two-dimensional picture plane. Emerson thought the painter's hand inferior to the photographic lens and the painter's canvas inferior to the light sensitive photographic plate.[39]

Emerson believed that true art was expressed only in "truth to Nature." He felt that wherever the artist had been true to Nature good art resulted. He stated ". . . as a means of artistic expression, the camera is second only to the brush — how successful the artist is with either depends entirely upon himself. All we ask is that the results be fairly judged by the only true standard — Nature!"[40]. Emerson codified all his teachings into the first manual on straight photography as an independent art, *Naturalistic Photography For The Students Of The Art,* published in 1889. In this book, he offered practical advice to the student of photography; such as the type of equipment to

8

use and the printing method best suited to reveal the full content of the negative. He firmly recommended two printing processes, photogravure and the platinotype.

Emerson made beautiful photographs of the English landscape and published these images in a series of monographs. All of the illustrations in Emerson's books were done by photogravure, with the exception of his first book, *Life and Landscape of the Norfolk Broads*, published in 1886. He co-authored this book with his good friend, T. F. Goodall, the landscape painter and naturalist. This exquisite monograph was published in a deluxe edition of 100. Each book was bound in green Moroccan leather and contained 40 original platinum prints.

The visual qualities inherent in platinum prints were of critical importance to Emerson's aesthetics. He stated, "For low tone effects and grey day landscapes, the platinotype process is unequalled. Every photographer who has the good and advancement of photography at heart should feel indebted to Mr. Willis for placing within his power a process by which he is able to produce work comparable on artistic grounds with any other black and white process. . . . No artist could rest content to practice photography alone as art, so long as such inartistic printing processes as the pre-planitoype process were in vogue. If the platinotype process were to become a lost art, we for our part, would never take another photograph."[41]

An editorial comment in the March 29th, 1899 edition of the *Photographic Journal* stated ". . . we are glad to see that Dr. Emerson thinks there is but one process for printing and that is the platinotype, and perhaps he has done more to show that artistic photographs can be produced by its means than any one else."[42]

Unfortunately, this enthusiasm was soon to be ended by none other than Emerson himself. Influenced by the research and discoveries of two scientists, Hurter and Driffield, and a conversation with a "famous painter," Emerson renounced his original belief that photography was an art. Hurter and Driffield were both amateur photographers. They found the rule of thumb methods of exposure and development used by most amateurs too inexact for their own use. They decided to find a more controlled and predictable system of exposure and development. Using an ordinary candle for illumination and a commercial sewing machine to operate the shutter they eventually discovered the relationship between exposure, density and development known as the "characteristic curve."[43]

The important impact of their discoveries on Emerson's theories was that no chemical or manual manipulation could alter the relation of one tone to another, a dark tone would always remain darker than a light tone. Emerson had firmly believed that these manipulations and controls were available to the photographer and that he could change the relation of tones at will. Accepting the discoveries of Hurter and Driffield as accurate, he published a retraction of his initial ideas in a pamphlet titled *The Death Of Naturalistic Photography*, in 1891. The retraction concludes with the statement . . . "In short I throw my lot in with those who say that photography is a very limited art. I deeply regret that I have come to this conclusion."[44]

Fortunately for photography, Emerson's retraction did not stop the momentum that his original ideas and work had created. He seems to have misunderstood the positive contribution that Hurter and Driffield had given to all photographers. Many supporters of Emerson's initial ideas took up the new techniques offered by Hurter and Driffield and applied these controls in the creation of their photographs. Although Emerson had firmly denounced his earlier ideas, he could not erase the visual fact that his own platinum prints were truly beautiful works of art.

Advocates of straight photography continued to champion the cause after Emerson's departure. They began to form photographic societies, initially in Europe and later in America. The first such union of amateur photographers was the Vienna Camera Club, founded in 1891. In the year of its founding, in the city of Vienna, the Club der Amateur-Photographer held the first International Exhibition of Photography. The importance of this exhibition was that it was the first group show dedicated to collecting the best international work without offering the traditional prizes and money awards that had become so controversial in the Salons of the Photographic Society of Britain.[45] The exhibition was organized by dedicated amateurs for the purpose of showing the serious work of the new generation of amateur photographers.

In 1892, the Linked Ring, an important photographic society was formed. The society was organized in London by Frederick Evans, H. P. Robinson, George Davison, A. Horsely Hinton, Lionel Clark and Hay Cameron. The purpose of the Linked Ring was to gather an elite group from the rank and file of amateur photographers. This select group of workers was intended to represent the most serious people then working with the medium.[46] Its initial manifesto expressed the

group's philosophy: ". . . the complete emancipation of pictorial photography from the retarding bondage of that which was purely scientific or technical, with which its identity had been confused too long, its development as an independent art and its advancement along these lines."[47]

One of the primary concerns of the Linked Ring was to establish the fundamental principles of straight photography and in particular the printing techniques that lent themselves to the group's avowed purposes. There was unanimous agreement that ordinary silver prints "were quite unsuitable for hanging on walls as pictures, to be admired at a distance."[48] A majority of the members resisted the use of any technique that interferred with the camera image. They chose to use the new platinotype process.

Frederick Evans, one of the most prolific members of the Linked Ring, worked exclusively with the platinum process. He chose this technique because it was capable of reproducing the rich tonal range of his negatives. His initial work was in the field of portraiture, particularly of his literary and artistic friends, but his most famous work dealt with the splendid interpretations of English and French cathedrals. With the inherent qualities of the platinum print, Evans was able to capture the brilliant shafts of light and subtle shadows of the great cathedrals.[49]

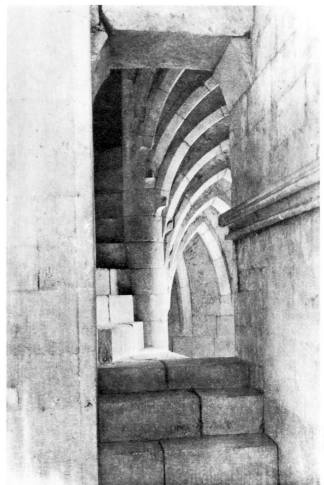

Evans/GEH

His earliest cathedral studies were the photographs of Yorkminister, begun about 1894 and followed by photographs of Lincoln Cathedral in 1896. Throughout the late 1890's and the early 1900's his photographs were exhibited in England and America and published in *Camera Work* from 1903 to 1907. Evans brought sensitive interpretation to architectural photography and elevated that branch of the medium to art.[50] In 1900, Edward Steichen called Evans' work the most beautiful rendering of architecture ever known; and in 1903, Stieglitz wrote, "He (Evans) stands alone in architectural photography."[51]

In 1904, a group of photographers formed the International Society of Pictorial Photographers. They were dedicated to conserve and advance photography as an independent medium of pictorial expression. A certain group within the Society were photographic purists in the fullest sense. They imbued ordinary objects, landscapes, architecture, portraits and still lifes with an artistic quality based on a sensitive interpretation of the subject. They rejected manual interference of the negative or the print. They chose to make their prints on platinum paper as they believed the process yielded the fullest range of delicate tones and low key highlights from their negatives.[52]

Only in Europe at this time was photography considered to be an art form. For this reason, a number of Americans felt the need to study, live and work in the more cultured climate of Europe and England. Among these men were Emerson, Alvin Langdon Coburn, and Alfred Stieglitz. Stieglitz began photographing while a student in Germany. He was, at the turn of the century, a most influential figure in photography in Europe and America. He was an active member of both the Linked Ring and the International Society of Pictorial Photographers. Before his return to New York City from Europe, in 1890, he was winning prizes for his beautiful prints made on the new Pizzitype paper. This was a platinum printing-out paper, not yet in general use at the time.[53]

When Stieglitz returned to New York he was shocked at the state of American photography. In Europe, photography was a controversial, yet highly regarded art form. In America, however, photography was regarded as a hobby, on a par with bicycling, and American photographers were almost unknown to their European counterparts. In 1893, Stieglitz became editor of the "American Amateur Photographer." His writings began to establish a set of principles by which a picture could be judged. These principles were simplicity, originality, tone, and atmosphere. About this same time, Stieglitz joined the Society of American Photographers of New York. Through his

energies this society merged in 1896 with the New York Camera Club to form the Camera Club of New York. Because of his experience as editor of the *American Amateur Photographer*, Stieglitz was selected as chairman of the publications committee of the Camera Club, in 1897. He began to edit and publish "Camera Notes," which later led to the classic "Camera Work."

In his own work, Stieglitz maintained a preference for platinum prints and photo gravure reproductions of platinum prints. Stieglitz had once called platinum the prince of photographic materials. He continually maintained that these were the two methods best suited to interpret the full tonal range of the negative. Always an innovator and experimenter, Stieglitz, along with another American photographer, Joseph T. Kieley, collaborated on a special method of platinum print development. They used a solution of potassium oxalate and glycerine to develop the image. The refinement of this new process culminated in an article Kieley wrote for *Camera Notes* in April 1900, entitled "Improved Glycerine Process For The Development Of Platinum Prints."[54]

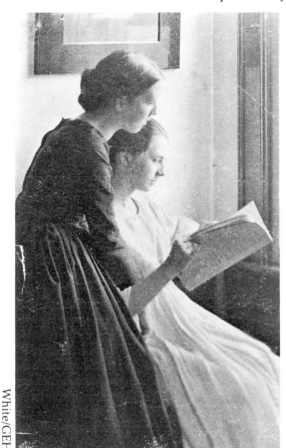

White/GEH

Stieglitz and Kieley used glycerin to retard the normal development action of the potassium oxalate developer, thus providing control similar to the dodging and burning of silver prints.

The years between 1896 and 1902 were crucial to Stieglitz and photography. In 1896, Stieglitz resigned as editor of *The American Amateur Photographer* where he had continuously imposed his strict standards. Photographers who didn't meet with his aesthetic demands in their work could expect rejection with the classic Stieglitz comment, "Technically good, pictorially rotten."[55] In 1902, at the age of 38, he was the respected authority in American photography. Stieglitz realized that the activities and publications of the Camera Club had outlived their function for him. He realized that his own individual achievements were not sufficient to win recognition for photography as an independent medium. Therefore, in that same year he formed a group of photographers and selected a name for the group, The "Photo-Secession." The fundamental aim of "Photo-Secession" was the advancement of pictorial photography. As its undisputed leader, Stieglitz gathered around him a select group of talented American photographers.[56]

Some of the more influential members of "Photo-Secession" were Gertrude Kasieber, Joseph Kieley, Clarence White, Edward Steichen and Alvin Langdon Coburn. The group's stated aim was:

"To advance photography as applied to pictorial expression. To draw together those Americans practicing or otherwise interested in art.

To hold, from time to time at varying places, exhibitions not necessarily limited to the productions of the Photo-Secession or to American work."[57]

"As a condition for its participation in outside exhibitions the Photo-Secession insisted that its collections be accepted, hung, and catalogued as an independent unit. The brilliance of the group's work usually won acceptance of its conditions and quickly brought international acclaim to American photography."[58]

Stieglitz also used the group's exquisite publication, *Camera Work*, as another tool against artistic ignorance. *Camera Work's* reproductions were photogravure reproductions printed on the highest quality Japan tissue. The beautiful reproductions set a standard of plate and image quality that has yet to be surpassed in American periodicals.[59]

Even with his involvement with Photo-Secession and his editorship of *Camera Work*, Stieglitz continued to photograph. His most important work from this period are platinum prints of unique beauty, made from 8 x 10 negatives. Virtually all of this work deals with two main themes — portraits of the continually changing face of New York City, and portraits of his closest friends. These two groups of portraits were all of subjects he knew well. Many of the prints "move to the heart of the subject with an inner strength and authority. Made on platinum paper, these prints have a brooding poetic quality, as well as one of great loneliness."[60]

Clarence H. White, the teacher and member of the Photo-Secession, wrked almost exclusively in platinum. The compositions of his platinum prints were limited to the most essential pictorial

elements and exhibit strong oriental influences. Sensitive asymmetrical balance, the arrangement of figures and objects parallel to the picture plane, and limited recessions of depth are all evident in his photographs. White's pints exhibit a limited tonal range toward the low end of the value scale. He avoided strong contrast, preferring instead, to convey the mood of the subject through subtle difference in tone. His use of the platinotype permitted exquisite graduated tones of black and gray, even in the shadows.[61] Clarence White's contribution was not solely in the area of imagery. Together with Max Weber, he founded the Clarence White School of Photography in New York City. White was renowned as a great teacher, exemplified by the later achievements of his students, Margaret Bourke-White, Dorothea Lange, Doris Ulmann, Ralph Steiner, Paul Outerbridge, Anne W. Brigman, Laura Gilpin and Karl Struss. These last three photographers, Anne W. Brigman, Laura Gilpin and Karl Struss made great use of the platinum printing techniques taught by White. Karl Struss went on to devise a method of coating paper on both sides with platinum, and then printing each side in register to produce a richer image.

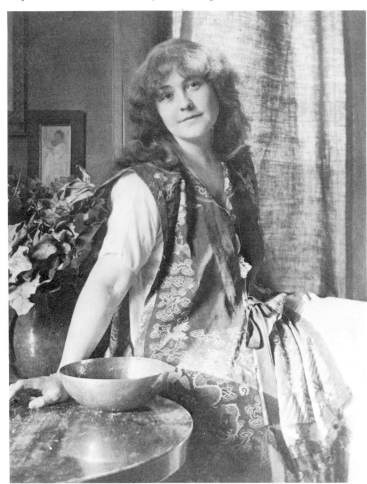

Kasieber/GEH

"Gertrude Kasebier coated platinum on Japan tissue to realize a medium in which light from the paper surface below was reflected back through to give a special luminous quality to the image."[62] Many of Kasebier's photographs deal with a highly romanticized and idealized interpretation of the classic theme of mother and child. Her choice of platinum lent itself to the soft and delicate nature of her subject.

Alvin Langdon Coburn chose to use platinum paper and the gum platinum process for printing many of his images. Concerning the platinotype and the gum platinum process, Coburn wrote, "I myself am a devotee of pure photography which is unapproachable in its own field . . . The platinum and gum platinum processes which I use, though complicated are purely photographic . . . By super-imposing the gum image over the platinum image an intensification of the shadows results. The whole process added a lustre to the platinum base comparable to the application of varnish, at the same time preserving the delicacy of the highlights in the original platinum print . . . To my regret, platinum paper was no longer made after W.W.I., for it gave very delicate gradations of tone and had the advantage of absolute permanence."[63]

Coburn was also "foreign correspondent" for a magazine published in the United States beginning in January of 1914 called *Platinum Print*, edited by Edward R. Dickinson. Coburn, in an article published in the magazine in February of 1915 (Vol. 1, No. 7) entitled "British Pictorial Photography" states, "In my opinion, platinum and photogravure are the two most adequate means of interpreting a photographic negative, combining as they do permanence with subtlety of tone rendering."[64] In an edition a month earlier, Spencer Kellogg reviewed an exhibition in Pittsburgh stating, "In comparing platinum prints with other work shown at Pittsburgh, the superiority and appropriateness . . . seemed unquestionable."[65] Clarence White, Karl Struss, Frederic Goudy, and Paul Anderson served as associate editors of the magazine.

In his books, *The Technique of Pictorial Photography*, and *The Fine Art of the Photograph*, Paul Anderson described the use of both commercial and hand sensitized platinum paper. He explains the application of platinum printing to various aspects of photography such as, winter scenes, architecture, and portraiture. Anderson states, "For contact printing, platinum or its newer

12

equivalent palladium is probably superior to anything else . . ." No silver paper he adds, has "the scale, the surface quality nor the permanence of platinum."[66]

One of the last photographers from the "Photo-Secession" era to work extensively with platinum printing was Paul Strand. Strand entered the Stieglitz circle of influence around 1916. "Stieglitz saw in Strand the hope for the future and described him as "a young man I have been watching for years, without doubt the only important photographer to emerge in the United States since Coburn. His prints are more subtle, and he has actually added some original vision to photography . . . Straight all the way through in vision, in work and in feeling, and original."[67]

Beaumont Newhall states, "Strand is a brilliant printer. Until it went off the market in 1937, he preferred platinum paper. It will be remembered that this paper was prized by

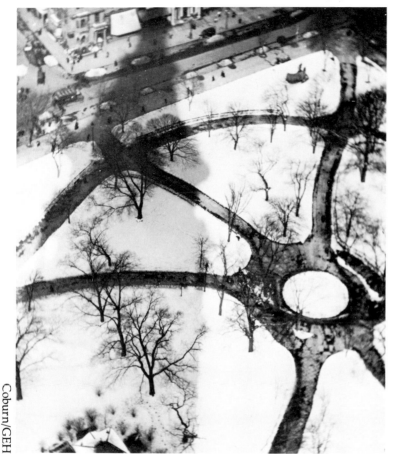

Coburn/GEH

Emerson for its ability to yeild soft results emphasizing the middle tones at the expence of highlights and shadows. Strand used to make brilliant low scale prints. Not content with Japine platinum paper which had a smooth, semi-matte surface, he persuaded the manufacturers, The Platinotype Company, of London, to produce double coated paper, after demonstrating to them the improved results which such paper could produce."[68]

Strand experimented with ways to deepen and enrich the tones of his platinum prints by adding to the prepared paper a platinum emulsion he had made himself and then gold toning the print to intensify the blacks. His results astonished other photographers. Walker Evans once said that Strand's original platinum print, titled "Blind Woman" influenced his whole development as a photographer.[69]

Strand preferred to work in platinum and only stopped using the paper when it became commercially unobtainable. He often said sadly, "that any photographic material of high cost and superior quality was apt to become unobtainable sooner or later, because the (photo) industry was geared to producing for the amateurs who have made photography the world's most popular hobby."[70]

The use of platinum was not confined solely to Europe, England, and the East Coast of the United States. Anne Brigman, a California pictorialist who studied with Clarence White, made her first platinum prints in 1911. A considerable number of Ansel Adams' early prints were done on platinum paper. Edward Weston mentions in his Daybooks, his use of platinum paper when he could afford it. However, with the increased cost of platinum and the difficulties involved in obtaining the paper, fewer and fewer people made platinotypes after World War I.

The commercial unavailability of platinum paper did not solely account for the decline in the popularity of the platinotype. By the beginning of World War I, photography was widely accepted as an art form in America. Thus, what was left of the Photo-Secession began to disintegrate. Pictorialism as an aesthetic declined. Newer trends from European painting, Impressionism, Cubism, Dadaism, became more influential. With the advent of smaller cameras, and smaller negatives, contact printing became less important. Photography and photographers became more interested in social concerns reportage, documentation and realism. With only a few exceptions, the platinotype fell into disuse.

Photographers today use the platinotype for the same reasons it was popular around the turn of the century. There is still that reverence for the "straight" platinum or palladium print. Although the platinotype possesses the possibility for manipulation, the major emphasis is still

directed toward the unmanipulated contact print. The content of much of the imagery in platinum has direct connection to the older platinum images, portraiture, landscape, and architecture. A situation not unlike the period of time in the 1880's and 1890's may be occurring today. As the "amateur" photographers of that earlier time brought fresh ideas to photography, perhaps the increase in the numbers of people making platinum images will bring new concepts and imagery to this area of the medium of photography.

THE
PLATINUM
PRINT

THE

PLATES

INTRODUCTION TO THE PLATES

In the past few years there has been a renaissance of turn-of-the-century, hand-applied, non-silver processes. In addition to platinum, such "obsolete" processes as gum bichromate, bromoil, photogravure and cyanotype are being employed for many of the same reasons they were admired originally: variety of effects, variable printing surface, involvement of the photographer at all stages, uniqueness of print and the opportunity for radical manipulation during printing.

The very obsolescence of the process is a positive factor of platinum's appeal. The paper cannot be purchased. The photographer must take an active role in its preparation. Results of several crucial choices combine to make a print: the ratio of gold chloride or mercuric chloride to platinum determines the warmth of the print; the texture of the paper to be coated affects the look and feel of the print, and, of course, the choice of a subject which will enhance and be enhanced by platinum printing.

Manipulation for its own sake has played almost no part in these pictures — gum bichromate would be a much better choice if manipulation were the sole aim. No, the chief advantage of the platinum process as described by Capt. Pizzighelli and Baron Hubl in 1883 in their book, *Platinotype,* is the "peculiar character of the pictures." Besides the permanence of the process, the lack of gelatin allows the platinum to be absorbed by the paper lending a softness to the print. (Gelatin is the substance which holds the light sensitive material, such as silver nitrate, in place and is contained in all commercially produced printing papers.) Thus, when looking at the photograph, the viewer is aware of the quality of the image surface and the high level of craftsmanship necessary to realize the print.

Peter Henry Emerson preferred platinum over gelatin processes believing the latter to have false tonalities. He complained that the blacks were too black, thereby forcing the photographer to lower all the tones in the photograph to keep them in balance. A champion of platinum's delicate middletones, he was quick to see that this printing subtlety would have little appeal for those Philistines he referred to as " 'fire,' 'snap,' 'sparkle,' and Co."

The necessity of contact printing enhanced platinum's ability to render fine detail and encouraged the use of large negatives. The large format cameras, in turn, forced a certain stillness to the scene — landscapes, posed models, buildings. Like artists in any media, photographers played to platinum's particular strong points. It is no accident that our favorite platinum prints are unimaginable in any other process.

Today's platinotypes are also contact printed, although the camera negative may be enlarged before printing. The critical question at this point is — having chosen to work in an antique process, can one adapt it to a contemporary vision or is this necessary? It's hard to say whether the platinum tradition infringes on contemporary images. One senses that the photographers included in this show approach their work as Frederick Evans and Gertrude Kasebier did, and are probably familiar with their predecessors' photographs. The point is, no one included in this volume is working in an historical vacuum, but the best contemporary work is a translation of an antique process into a contemporary vocabulary.

The work presented here swings all the way from traditional subjects to the completely ironic; the irony resulting from the photograph's head-on collision with that tradition. The same process rendered Frederick Evans' "Sea of Stairs," and "Shooting Gallery — Glen Echo" by Steve Szabo, two prints seemingly different sharing a common heritage of thought.

In Geoffrey Ithen's "Coney Island," the deserted amusement park becomes a fantastic landscape filled with strange mechanical devices. The meticulous detail gives no clue to what these objects apparently in disuse are made for. The frail cirrus clouds overhead are in sharp contrast to the airless man-made deserted landscape. As in Steven Livick's untitled urban landscape, a perfect desolation reigns. The platinum process which can bring life to stone and rough textures can also execute the cold sheen of metal. That quality which in the older work was translated as remote and exotic within the context of Romanticism can now serve as a sign of alienation, "quiet, desperation." The confusion of lines and planes, fences, structures looming ominously out of the picture create a claustrophobic atmosphere of suffocation. Lost in reproduction is Livick's use of the heavy paper stock on which the image is printed. Not only are clouds absent from the sky, there is nothing but highly textured paper, bringing us back to the surface of a photographic print, a two-dimensional space. Instead of closing out the viewer by acknowledging the cold photographic surface, in Phil Davis' portraits of "Jerry Stratton" and "Pat Murphy," the texture of the paper has become the texture of the skin, producing a certain sense of vulnerability. By contrast, in "Janis Lipzin" and "Evelyn Milligan," two enigmatic female portraits by Nancy Rexroth, the subjects appear removed, isolated. These women do not confront the viewer with a hard stare but seem to float tranquilly in a shallow space. At first glance odder than the male portraits, the lighter, softer tones, the reticence of the sitter and smallness of print size recall an older sensibility.

Only a few prints have been chosen for discussion but this is not to dismiss other work, such as George Tice's exquisitely beautiful, shadowless landscape or the Mark Schwartz prints both entitled, "Athens, Ohio," of personal systems and symbols.

The majority of pictures in the show are of quiet scenes, moments. Whether the contents of a particular photograph create a sense of two or three dimensional space, one is struck by the quality of the print surface. The strength of the image is founded on the process; where this interrelationship is the strongest the central concern of the photographs is truly the process itself.

Marianne Fulton Margolis
George Eastman House
April 1979

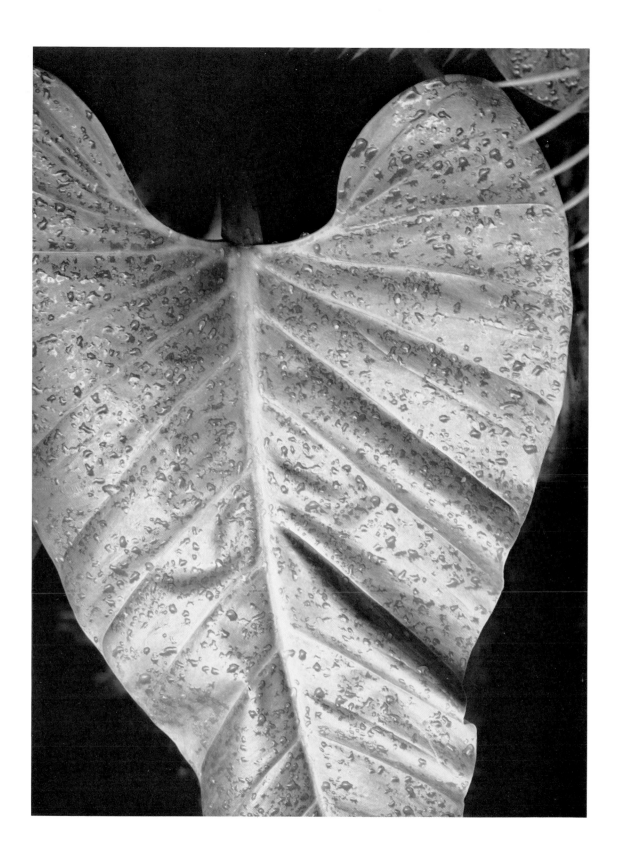

Plate 1. **Kipton Kumler,** #4 Elephant Ear, 1978, 25x35 cm

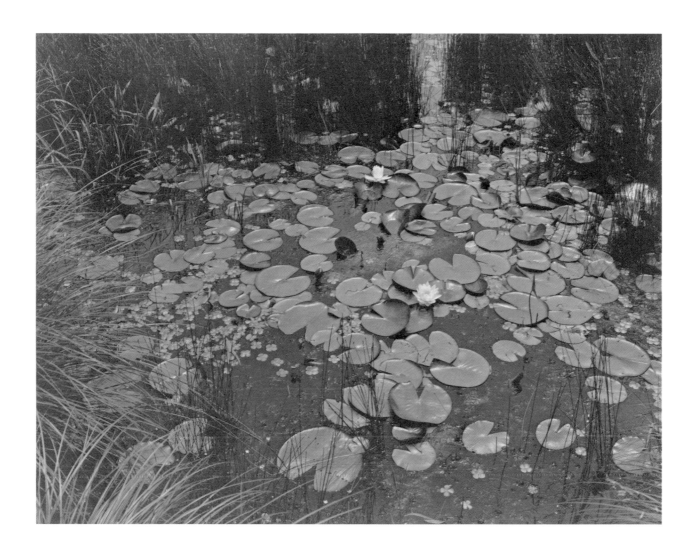

Plate 2. **George A. Tice,** Aquatic Plants #1 New Jersey, Palladium Print, 1967, 19.5x24.5 cm.

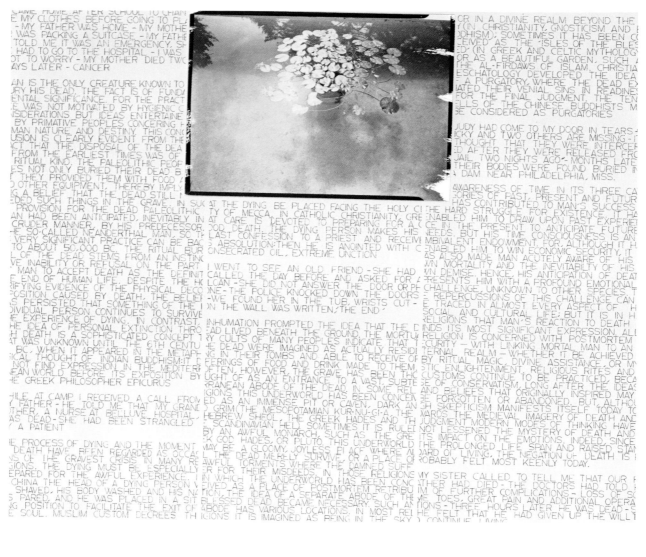

CAME HOME AFTER SCHOOL TO CHAN
E MY CLOTHES BEFORE GOING TO PL/
- MY FATHER WAS HOME - MY MOTHE
WAS PACKING A SUITCASE - MY FATHE
TOLD ME IT WAS AN EMERGENCY, S
HAD TO GO TO THE HOSPITAL - I WAS
OT TO WORRY - MY MOTHER DIED TWO
AYS LATER - CANCER

AN IS THE ONLY CREATURE KNOWN TO
RY HIS DEAD, THE FACT IS OF FUND/
ENTAL SIGNIFICANCE, FOR THE PRACT
E WAS NOT MOTIVATED BY HYGIENIC C
SIDERATIONS BUT IDEAS ENTERTAINE
BY PRIMATIVE PEOPLES CONCERING H
MAN NATURE, AND DESTINY, THIS CONC
USION IS CLEARLY EVIDENT FROM THE
CT THAT THE DISPOSAL OF THE DEA
FROM THE EARLIEST TIMES WAS OF
RITUAL KIND, THE PALEOLITHIC PEOP
ES NOT ONLY BURIED THEIR DEAD B
THEY PROVIDED THEM WITH FOOD /
O OTHER EQUIPMENT, THEREBY IMPL/
G A BELIEF THAT THE DEAD STILL
EDED SUCH THINGS IN THE GRAVE, IN SUC
PROVISION FOR THE DEAD PALEOLITHIC
AN HAD BEEN ANTICIPATED, INEVITABLY IN
CRUDER MANNER, BY HIS PREDECESSOR,
HE SO-CALLED NEANDERTHAL MAN, SO TH
VERY SIGNIFICANT PRACTICE CAN BE BAC
TO ABOUT 50,000 BC, THE RITUAL BUR
L OF THE DEAD STEMS FROM AN INSTINC
VE INABILITY OR REFUSAL ON THE PART
MAN TO ACCEPT DEATH AS THE DEFINIT
E END OF HUMAN LIFE, DESPITE THE H
RIFYING EVIDENCE OF THE PHYSICAL DECO
POSITION CAUSED BY DEATH, THE BELIEF
S PERSISTED THAT SOMETHING OF THE I
DIVIDUAL PERSON CONTINUES TO SURVIVE
HE EXPERIENCE OF DYING, IN CONTRAST,
HE IDEA OF PERSONAL EXTINCTION THRO
H DEATH IS A SOPHISTICATED CONCEPT T
AT WAS UNKNOWN UNTIL THE 6TH CENTU
BC, WHEN IT APPEARED IN THE METAPH
ICAL THOUGHT OF INDIAN BUDDHISM;IT
NOT FIND EXPRESSION IN THE MEDITERF
EAN WORLD BEFORE ITS EXPOSITION BY
HE GREEK PHILOSOPHER EPICURUS

HILE AT CAMP I RECEIVED A CALL FROM
Y FATHER - HE TOLD ME THAT MY GRAND
THER, A NURSE AT BELLUVE HOSPITAL,
AS DEAD - SHE HAD BEEN STRANGLED
A PATIENT

E PROCESS OF DYING AND THE MOMENT
DEATH HAVE BEEN REGARDED AS OCCA
NS OF THE GRAVEST CRISIS IN MANY RE
IONS, THE DYING MUST BE ESPECIALLY
EPARED FOR THE AWFUL EXPERIENCE, I
CHINA THE HEAD OF A DYING PERSON
SHAVED, HIS BODY WASHED AND HIS N/
PARED, AND HE WAS PLACED IN A SIT
G POSITION TO FACILITATE THE EXIT O
E SOUL, MUSLIM CUSTOM DECREES TH

AT THE DYING BE PLACED FACING THE HOLY CI
TY OF MECCA, IN CATHOLIC CHRISTIANITY, GRE
AT CARE IS DEVOTED TO PREPARING FOR A C
OD DEATH, THE DYING PERSON MAKES HIS
LAST CONFESSION TO A PRIEST AND RECEIV
ABSOLUTION;THEN HE IS ANOINTED WITH C
ONSECRATED OIL, EXTREME UNCTION

I WENT TO SEE AN OLD FRIEND - SHE HAD
CALLED THE DAY BEFORE AND ASKED FOR A
LOAN - SHE DID NOT ANSWER THE DOOR OR PH
ONE - THE POLICE KNOCKED DOWN THE DOORS
- WE FOUND HER IN THE TUB, WRISTS CUT -
ON THE WALL WAS WRITTEN; 'THE END'

INHUMATION PROMPTED THE IDEA THAT THE D
AD LIVED BENEATH THE GROUND, THE MORTU
RY CULTS OF MANY PEOPLES INDICATE THAT T
HE DEAD WERE IMAGINED AS ACTUALLY RESIDI
G IN THEIR TOMBS AND ABLE TO RECEIVE OF
FERINGS OF FOOD AND DRINK MADE TO THEM,
OFTEN, HOWEVER, THE GRAVE HAS BEEN THO
UGHT OF AS AN ENTRANCE TO A VAST SUBTE
RRANEAN ABODE OF THE DEAD, IN SOME REL
IGIONS THIS UNDERWORLD HAS BEEN CONCEI
ED AS AN IMMENSE PIT OR CAVEN, DARK AN
GRIM(THE MESOPOTAMIAN KUR-NU-GI-A THE
HEBREW SHEOL, THE GREEK HADES AND TH
SCANDINAVIAN HEL) SOMETIMES IT IS RULED
BY AN AWFUL MONARCH, SUCH AS THE GRE
K GOD HADES, OR PLUTO, THIS UNDERWORLD
MAY BE A GLOOMY, JOYLESS PLACE WHERE A
L THE DEAD MERELY SURVIVE, OR A PLACE O
AWFUL TORMENTS WHERE THE DAMNED SUFF
R FOR THEIR MISDEEDS, IN THOSE RELIGIONS
IN WHICH THE UNDERWORLD HAS BEEN CONC
EIVED AS A PLACE OF POSTMORTEM RETRIBU
TION, THE IDEA OF A SEPARATE ABODE OF THE
BLESSED DEAD BECAME NECESSARY, SUCH A
ABODE HAS VARIOUS LOCATIONS, IN MOST REL
IGIONS IT IS IMAGINED AS BEING IN THE SKY

CR IN A DIVINE REALM BEYOND THE
(IN CHRISTIANITY, GNOSTICISM AND
DDHISM); SOMETIMES IT HAS BEEN C
EIVED AS THE 'ISLES OF THE BLES
D' (IN GREEK AND CELTIC MYTHOLOG
OR AS A BEAUTIFUL GARDEN, SUCH /
THE AL-FIRDAWS OF ISLAM, CHRISTIA
ESCHATOLOGY DEVELOPED THE IDEA
A PURGATORY, WHERE THE DEAD E>
ATED THEIR VENIAL SINS IN READINE
FOR THE FINAL JUDGMENT, THE TEN
LLS OF THE CHINESE BUDDHISTS M
BE CONSIDERED AS PURGATORIES

JUDY HAD COME TO MY DOOR IN TEARS -
ICKY AND TWO OTHERS ARE MISSING -
THOUGHT THAT THEY WERE INTERCE
D AFTER THEY WERE RELEASED FR
JAIL TWO NIGHTS AGO'- MONTHS LATE
THEIR BODIES WERE FOUND BURIED I
A DAM NEAR PHILADELPHIA, MISS.

AWARENESS OF TIME IN ITS THREE CA
GORIES OF PAST, PRESENT AND FUTUR
HAS CONTRIBUTED TO MAN'S SUCCESS
THE HARD STRUGGLE FOR EXISTENCE, IT HA
ENABLED HIM TO DRAW UPON PAST EXPERIE
CE IN THE PRESENT TO ANTICIPATE FUTURE
NEEDS, BUT HIS TIME CONSCIOUSNESS IS AN
MBIVALENT ENDOWMENT, FOR, ALTHOUGH IT H
ENABLED HIM TO WIN ECONOMIC SECURITY, IT
AS ALSO MADE MAN ACUTELY AWARE OF HIS
WN MORTALITY AND THE INEVITABILTY OF HIS
WN DEMISE, HENCE, HIS ANTICIPATION OF DEAT
PRESENTS HIM WITH A PROFOUND EMOTIONAL
CHALLENGE, UNKNOWN TO OTHER SPECIES
E REPERCUSSIONS OF THIS CHALLENGE CAN
E TRACED IN ALMOST EVERY ASPECT OF H
SOCIAL AND CULTURAL LIFE; BUT IT IS IN H
RELIGIONS THAT MAN'S REACTION TO DEATH
INDS ITS MOST SIGNIFICANT EXPRESSION, ALL
RELIGION IS CONCERNED WITH POSTMORTEM
CURITY - WITH LINKING MORTAL MAN TO AN
TERNAL REALM - WHETHER IT BE ACHIEVED
BY RITUAL MAGIC, DIVINE ASSISTANCE, OR MY
STIC ENLIGHTENMENT, RELIGIOUS RITES AND
CUSTOMS CONTINUE TO BE PRACTICED, BECA
SE OF CONSERVATISM, LONG AFTER THE IDEA
AND BELIEFS THAT ORIGINALLY INSPIRED MAY
BE FORGOTTEN OR ABANDONED, BUT, ALTHOU
H SKEPTICISM MANIFESTS ITSELF TODAY TO
WARDS THE MEDIEVAL IMAGERY OF DEATH AND
JUDGMENT, MODERN MODES OF THINKING HAVE
NOT LESSENED THE MYSTERY OF DEATH, AND
ITS IMPACT ON THE EMOTIONS, INDEED, SINCE
THE PROLONGED LIFE SPAN AND RAISED STA
DARD OF LIVING, THE NEGATION OF DEATH IS
ROBABLY FELT MOST KEENLY TODAY.

MY SISTER CALLED TO TELL ME THAT OUR
ATHER HAD DIED - THE DOCTORS HAD TOLD
M OF FURTHER COMPLICATIONS - LOSS OF S
ME TOES, GREAT PAIN AND ADDITIONAL OPERA
IONS - THREE HOURS LATER HE WAS DEAD -
HE FELT THAT HE HAD GIVEN UP THE WILL T
CONTINUE LIVING

Plate 3. **Klaus Schnitzer/Robert Sennhauser,** Collaboration, 1978, 24x42.2 cm

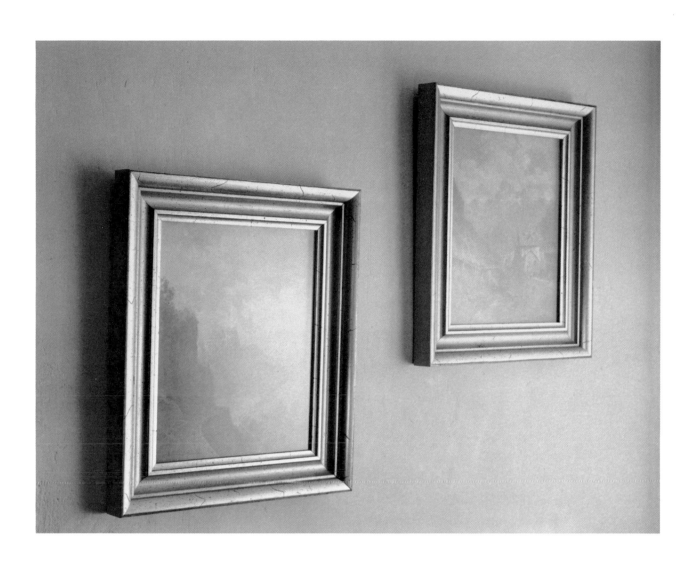

Plate 4. **Gibson Kennedy,** Two Frames, 1977, 19.5x24.5 cm

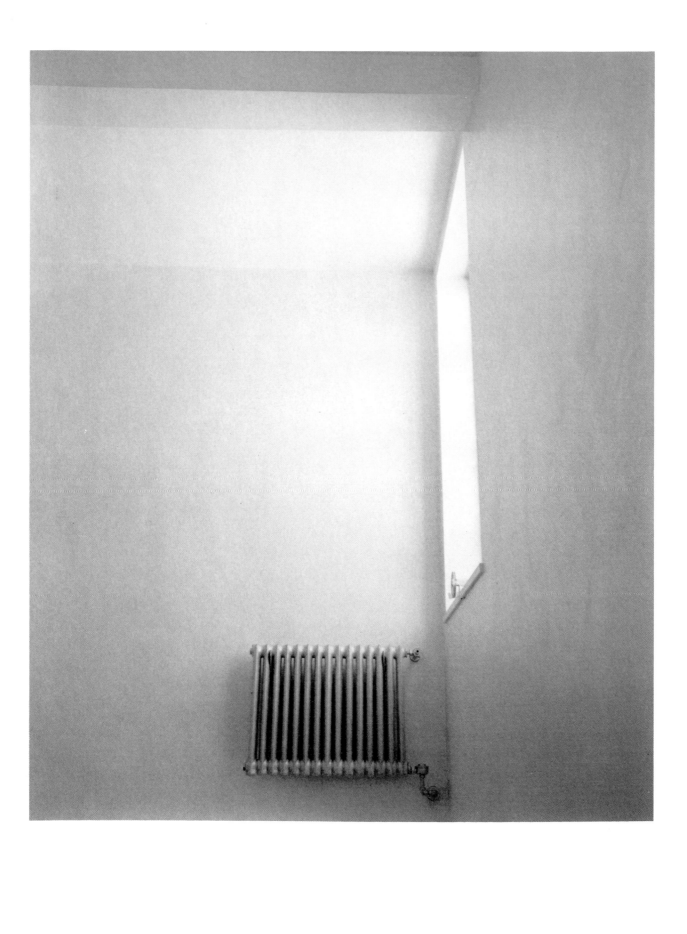

Plate 5. **Gibson Kennedy,** Malmkroot No. 1, 1978, 19.5x24.5 cm

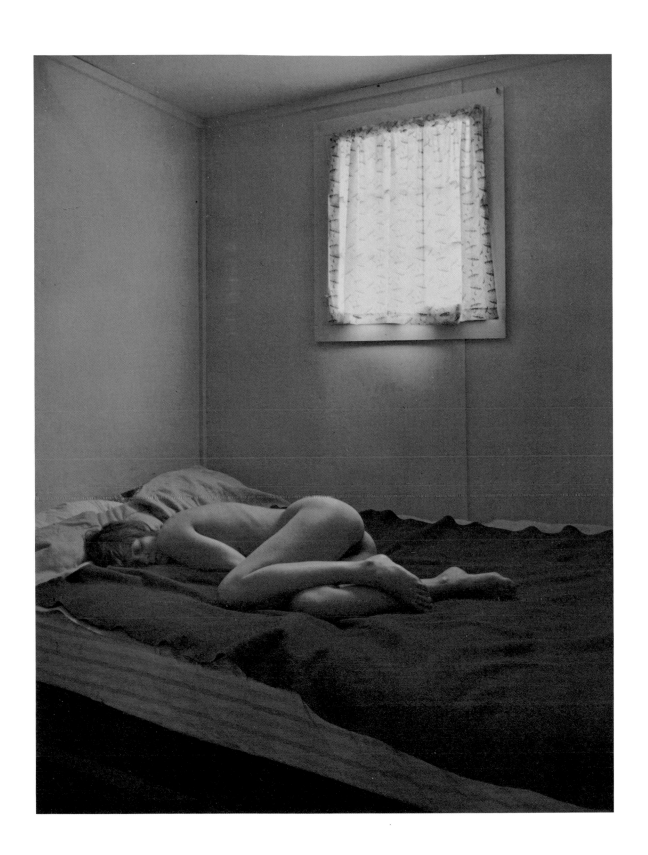

Plate 6. **Brian Lav,** Susan, Palladium Print, 1975, 16.5x21.5 cm

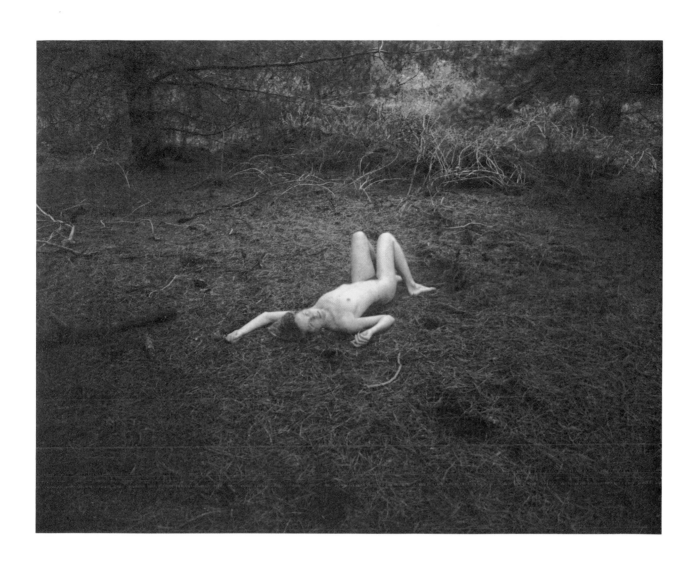

Plate 7. **Tom Millea,** Nude - Point Lobos, 1978, 19x24 cm

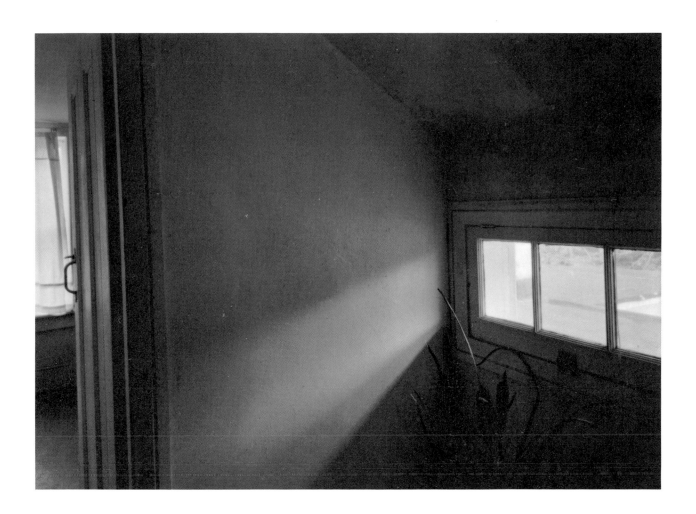

Plate 8. **Sandy Noyes,** Peters Valley, N.J., 1978, 12x17 cm

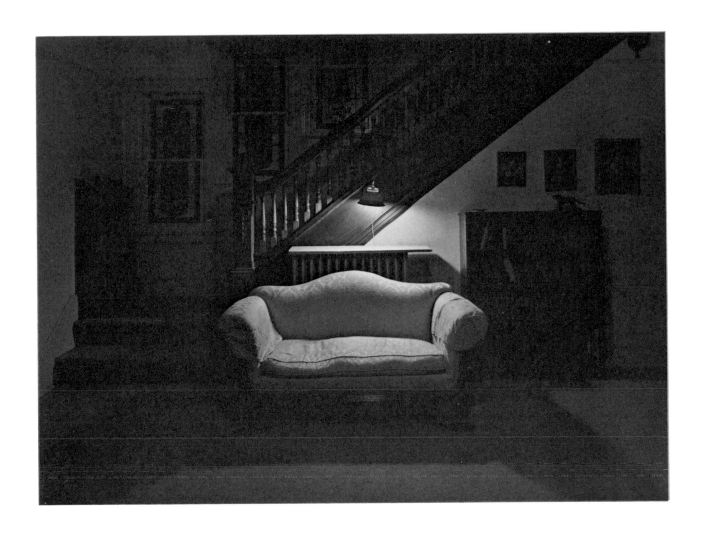

Plate 9. **Brian Lav,** Couch, Palladium Print, 1976, 15.8x21 cm

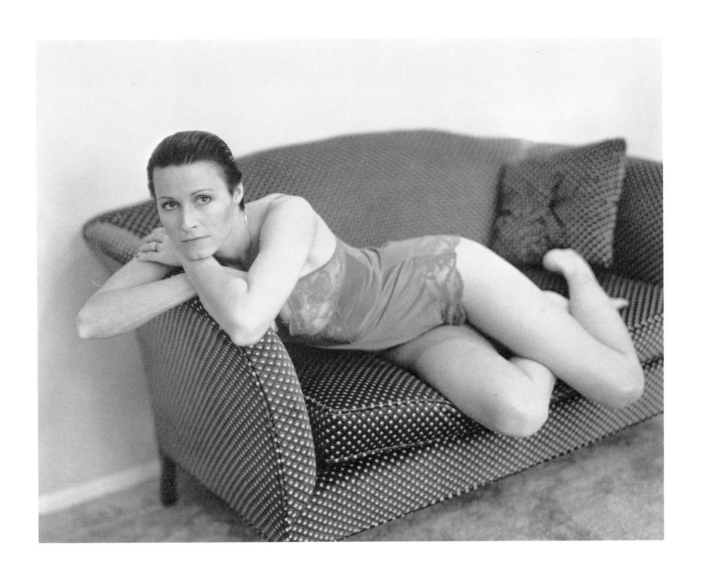

Plate 10. **Tom Shillea,** Jo Ann, 1978, 19.5x24.5 cm

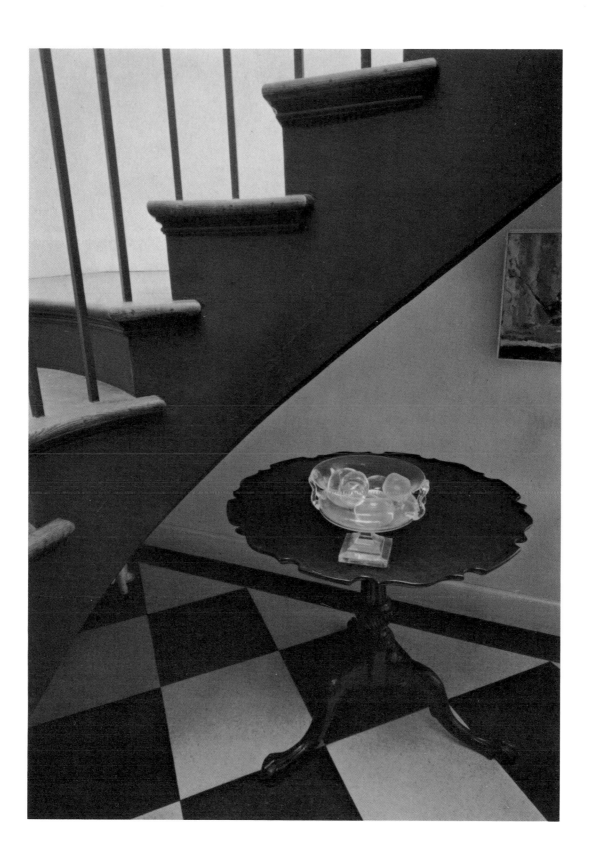

Plate 11. **Sandy Noyes,** Gloucester, Mass., 1978, 12x17 cm

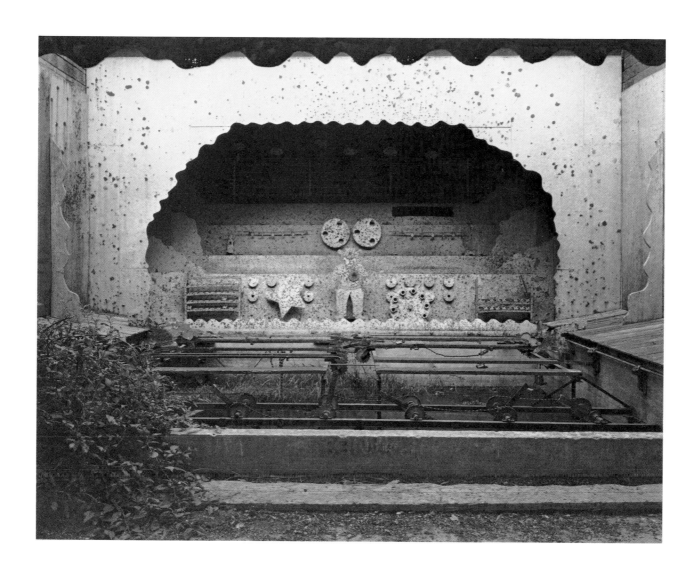

Plate 12. **Steve Szabo,** Shooting Gallery, Glen Echo, 1978, 19.5x24.5 cm

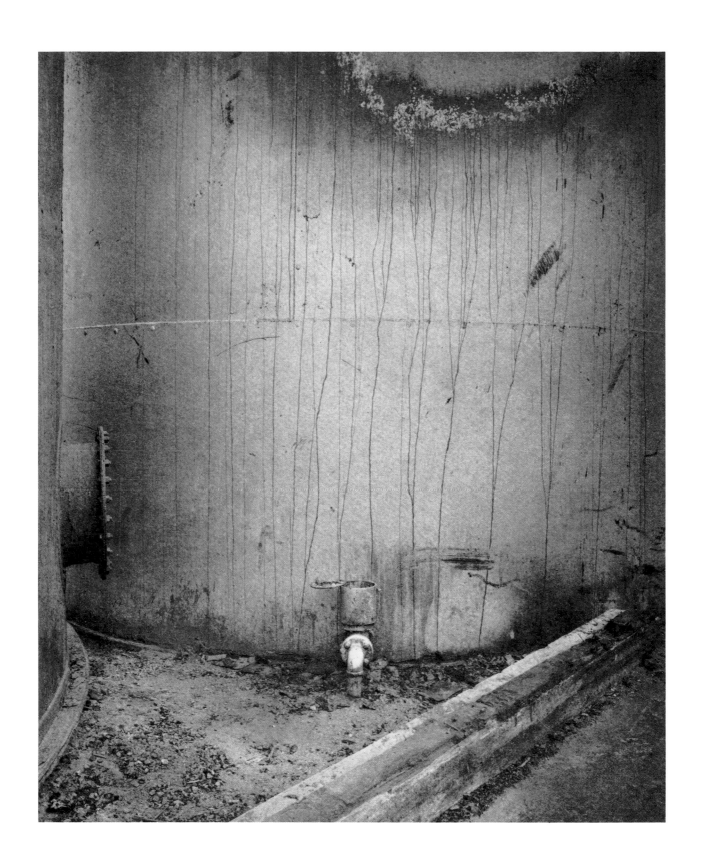

Plate 13. **Joan Myers,** L.A. Landscape VII, Palladium and Pastel, 1978, 26x34.5 cm

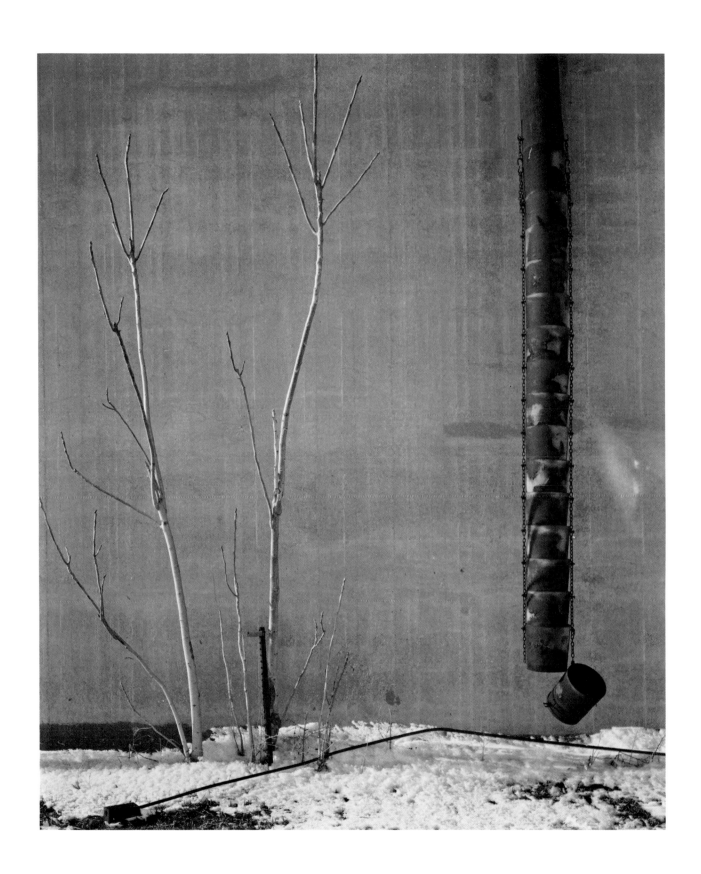

Plate 14. **Alan Newman,** untitled, 1978, 19.5x24.5 cm

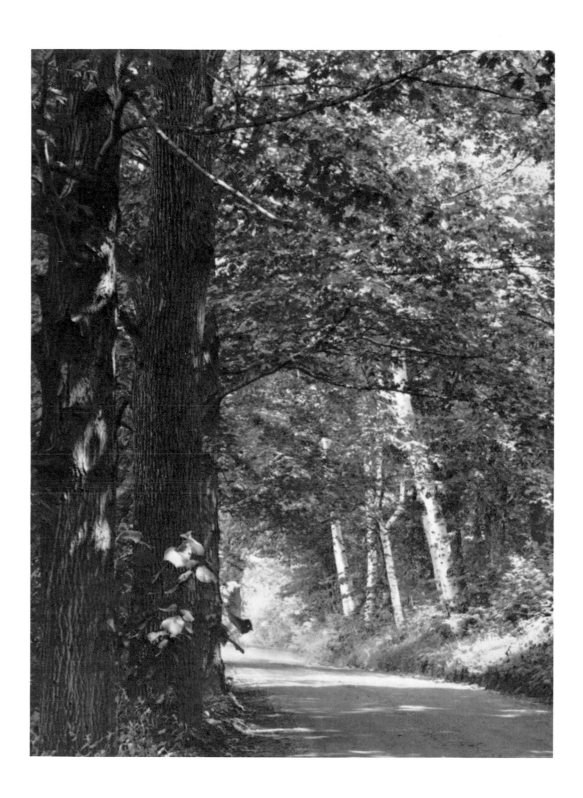

Plate 15. **William Stainton,** Seven Mts., Pa., 1978, 11.8x16.7 cm

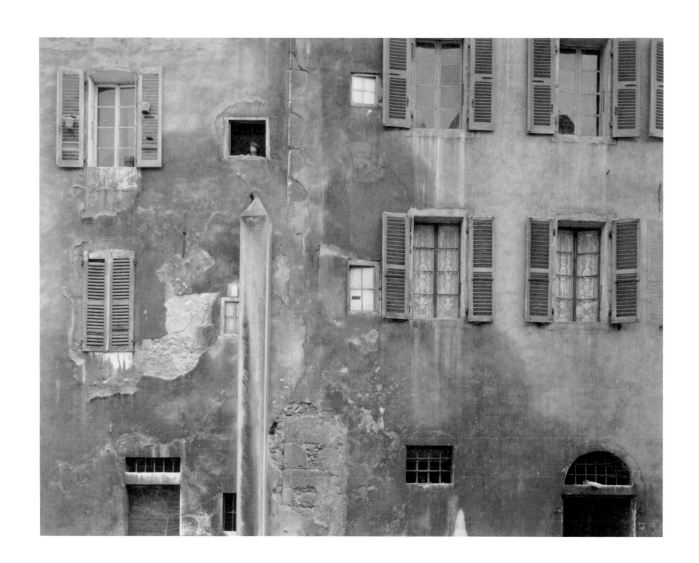

Plate 16. **Lois Conner,** Wall-Annecy France, 1978, 19.5x24.5 cm

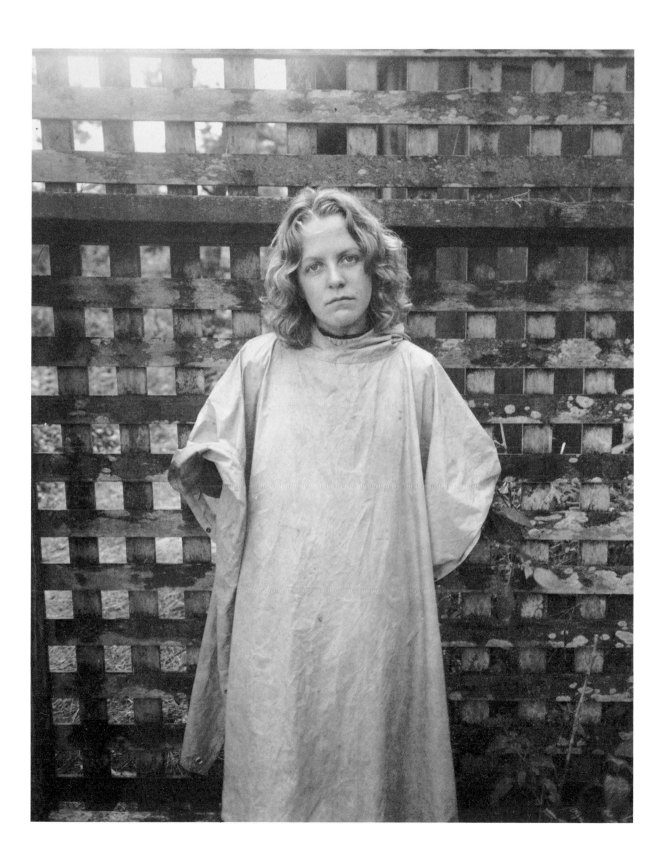

Plate 17. **Tom Millea,** Teri Craig, 1978, 19x24 cm

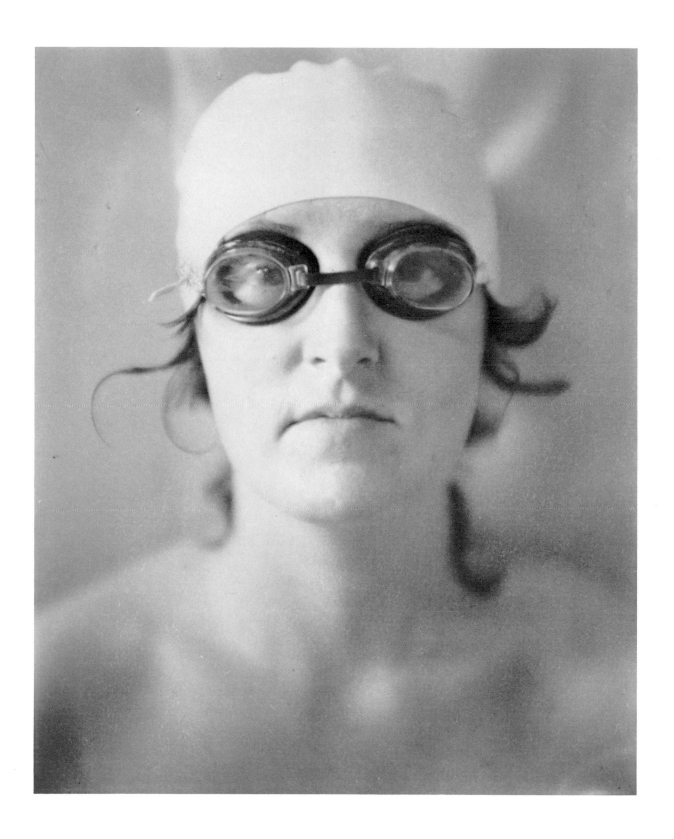

Plate 18. **Nancy Rexroth,** Nancy Lipzin, 1978, 9.5x12 cm

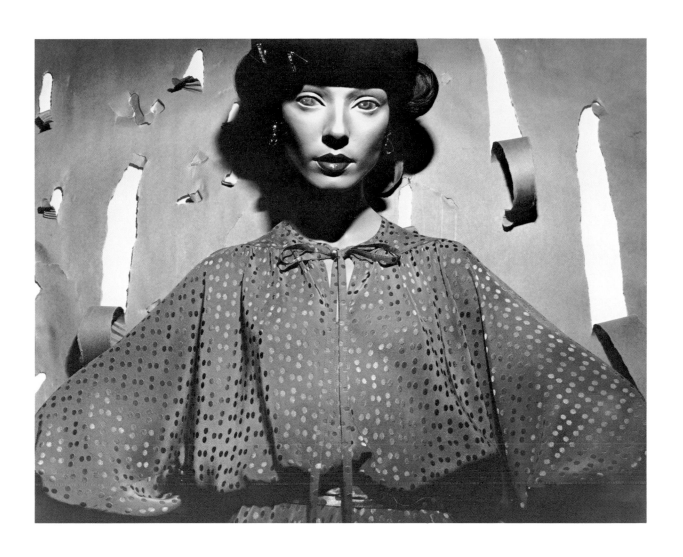

Plate 19. **Steven Livick,** untitled, 1978, 43.5x55.2 cm

Plate 20. **Phil Davis,** Pat Murphy, N.D., Palladium Print, 18.5x24.5 cm

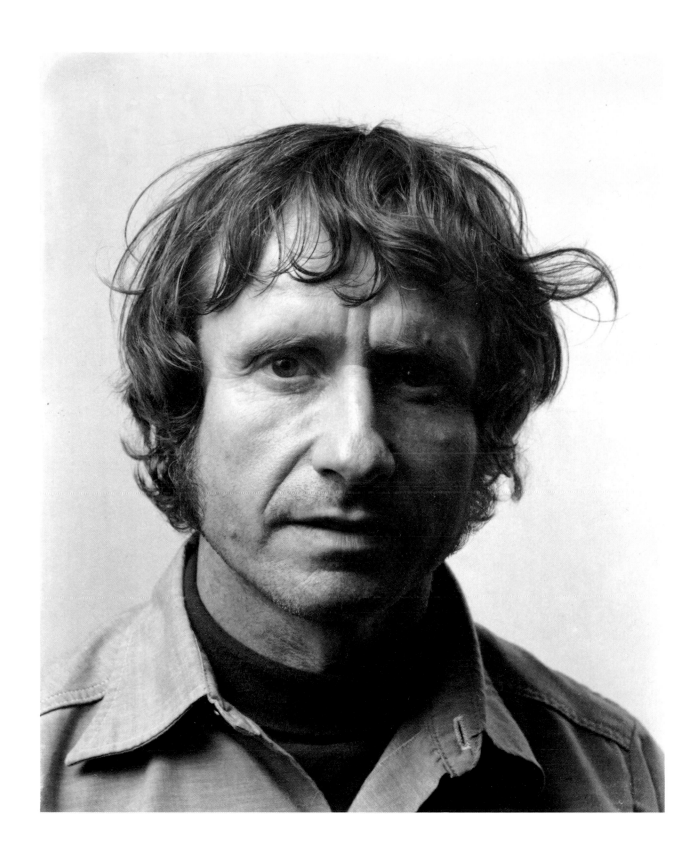

Plate 21. **Phil Davis,** Jerry Stratton, N.D., Palladium Print, 18.5x24.5 cm

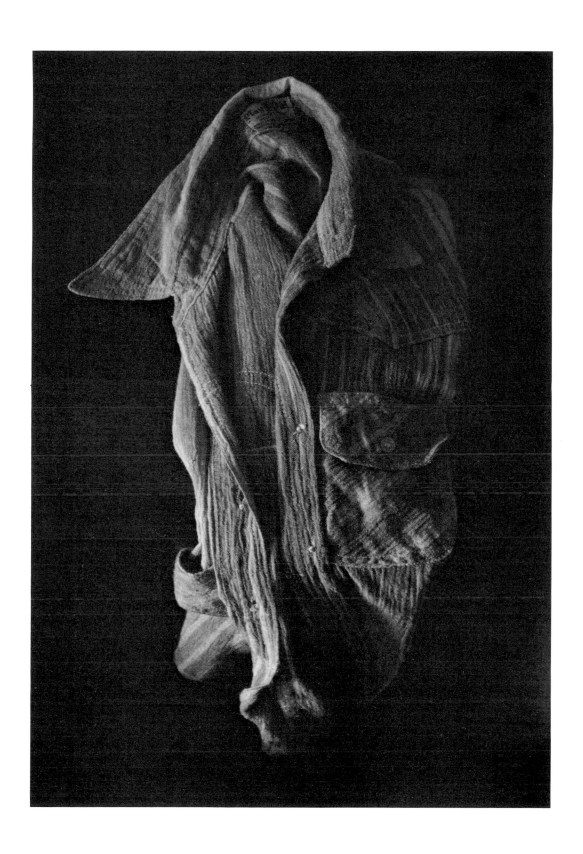

Plate 22. **Tom Davies,** Shirt, 1978, 11.6x16.6 cm

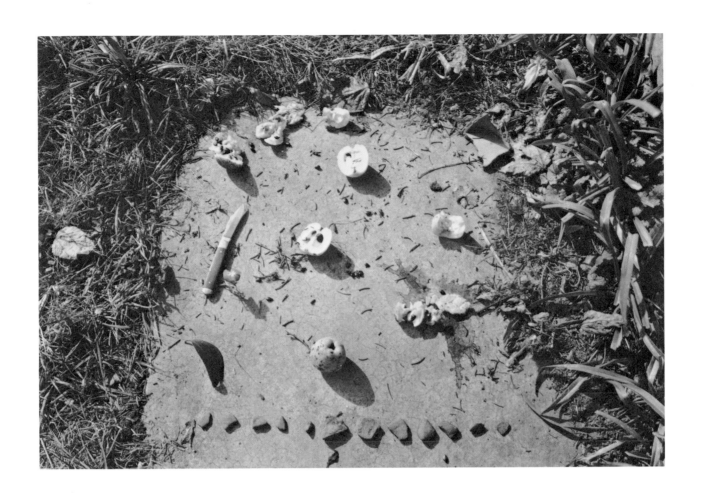

Plate 23. **Mark Schwartz,** Athens, Ohio, 1978, 12x17 cm

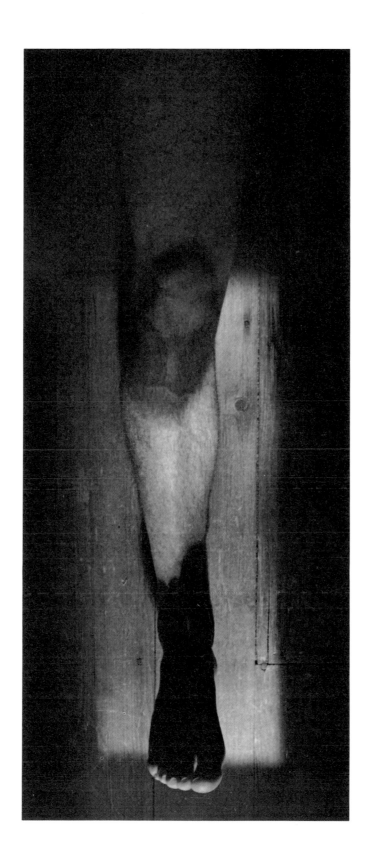

Plate 24. **Tom Davies,** Leg, 1977, 6.2x14.2 cm

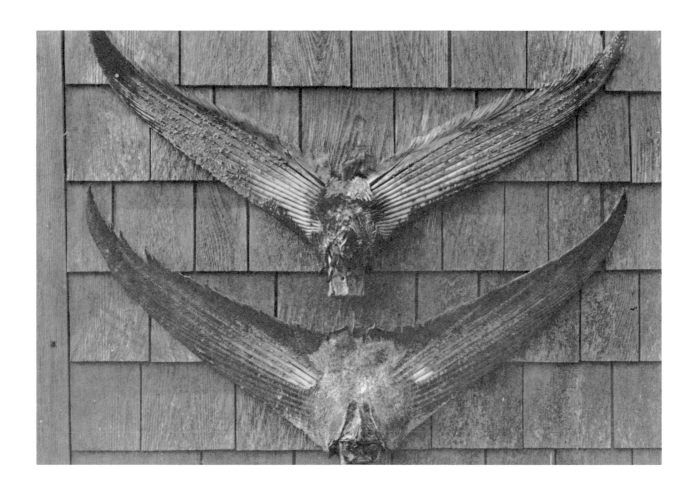

Plate 25. **Jeffrey Kay,** Wings, Monhegan Island, 1978, 12x17 cm

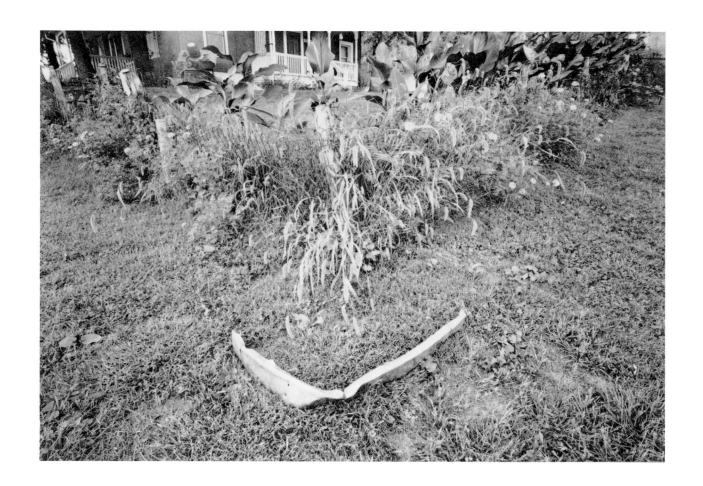

Plate 26. **Mark Schwartz,** Athens, Ohio, 1978, 12x17 cm

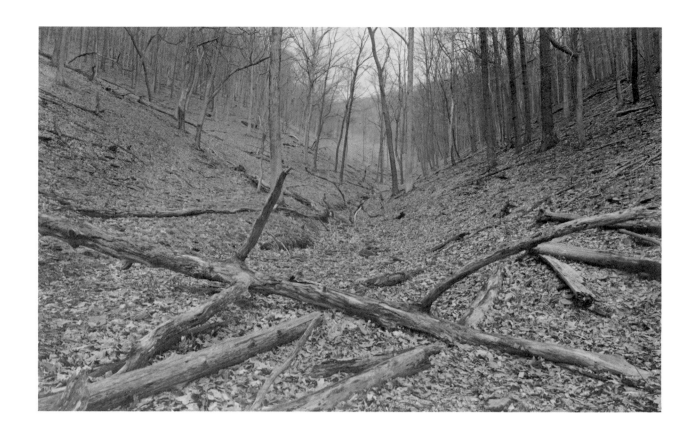

Plate 27. **Jeffrey Kay,** Driftwood, Pennsylvania, 1978, 17x27.2 cm

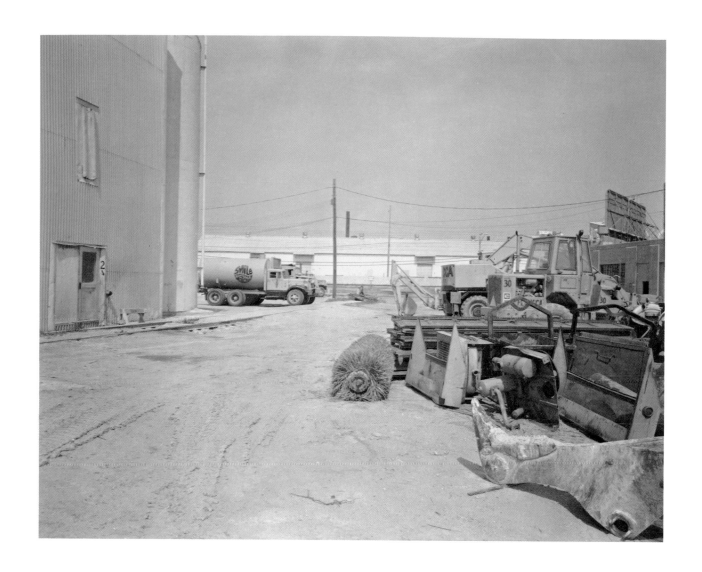

Plate 28. **Alan Newman,** untitled, 1979, 19.5x24.5 cm

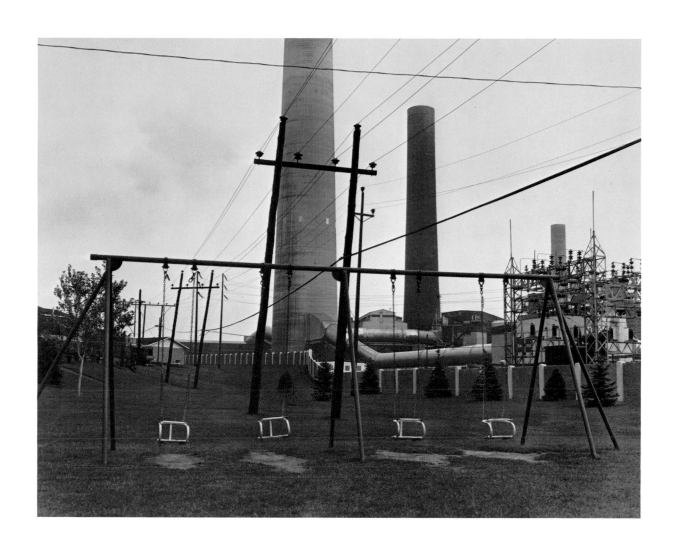

Plate 29. **Steven Livick,** untitled, 1978, 43.5x55.2 cm

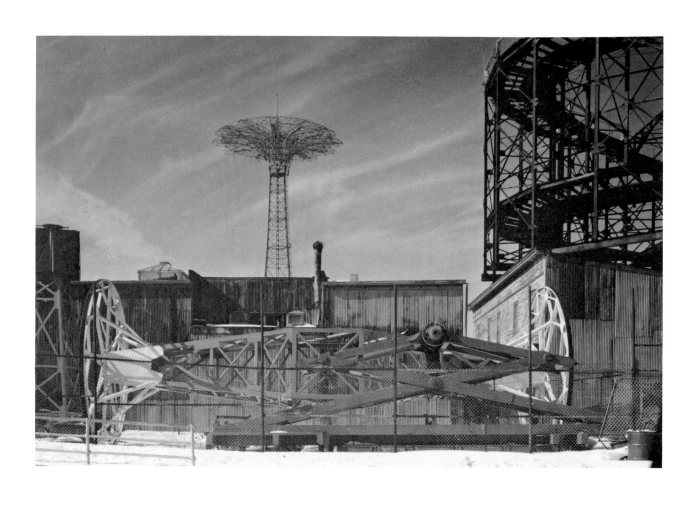

Plate 30. **Geoffrey Ithen,** Coney Island, 1978, 12x17 cm

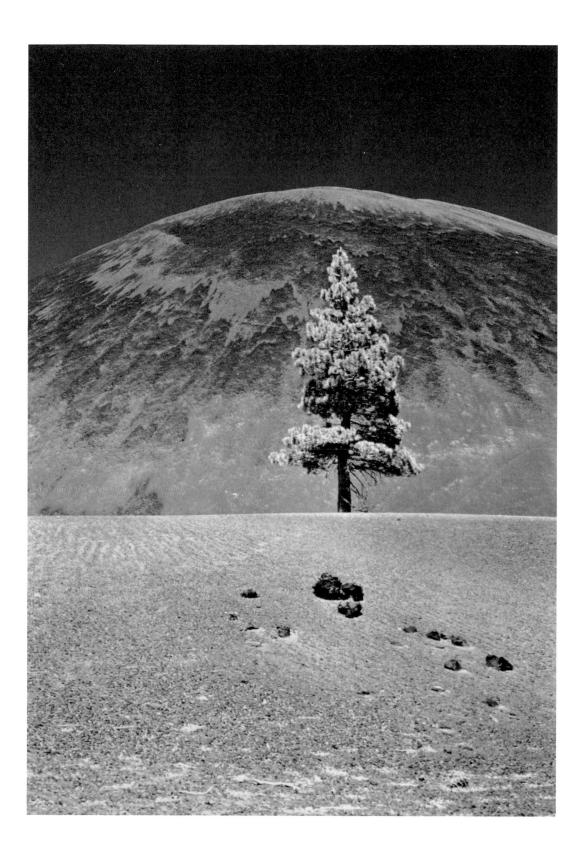

Plate 31. **John Hafey,** Lassen, Cal., 1978, 16.5x24 cm

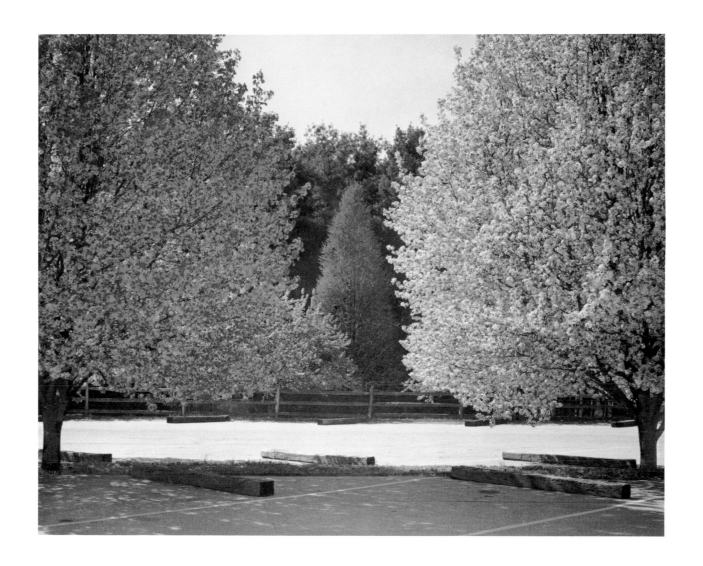

Plate 32. **Lois Conner,** Parking Lot, Longwood Gardens, Pa., 1977, 19.5x24.5 cm

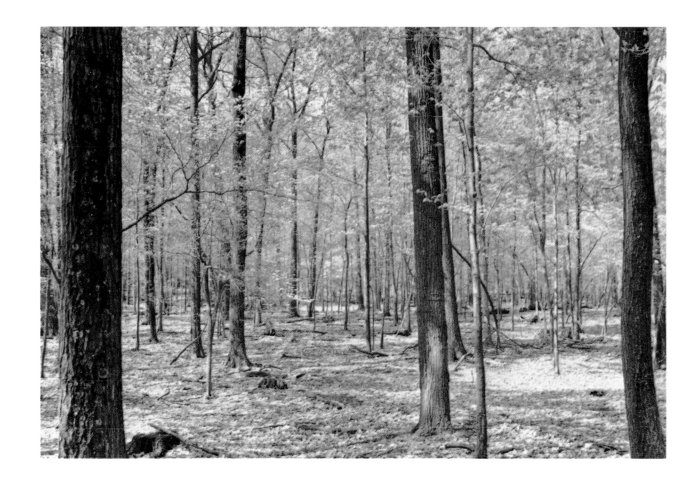

Plate 33. **William Stainton,** Birches, Puthey, VT., 1978, 16.5x24 cm

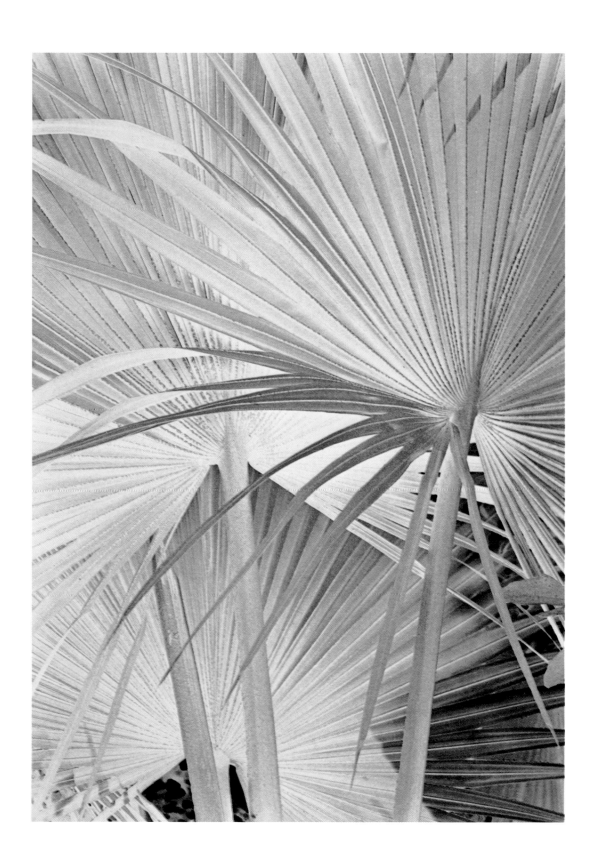

Plate 34. **John Hafey,** Palm Ferns, 1978, 16.5x24 cm

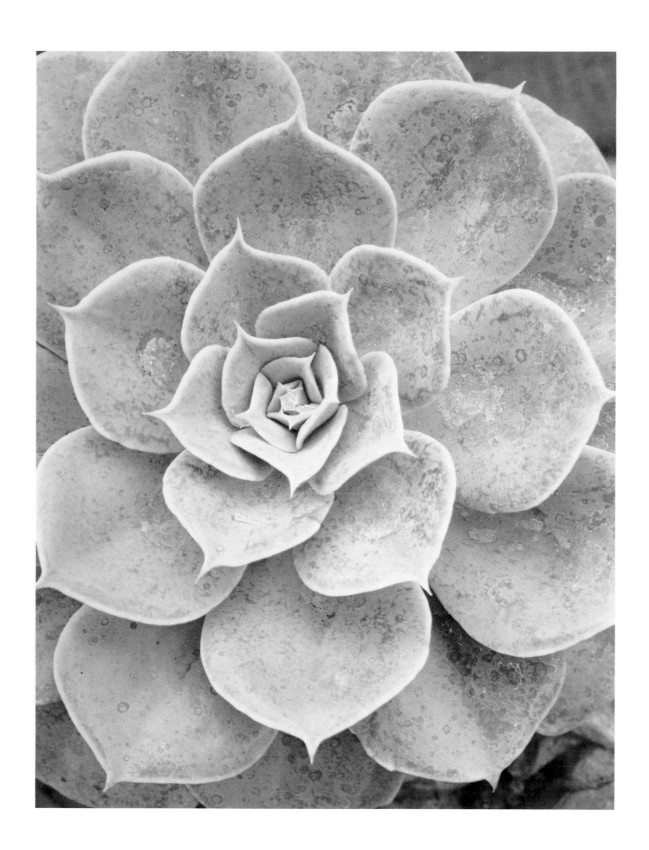

Plate 35. **Kipton Kumler,** Succulent Plant, 1977, Platinum/Palladium Print, 25x35 cm

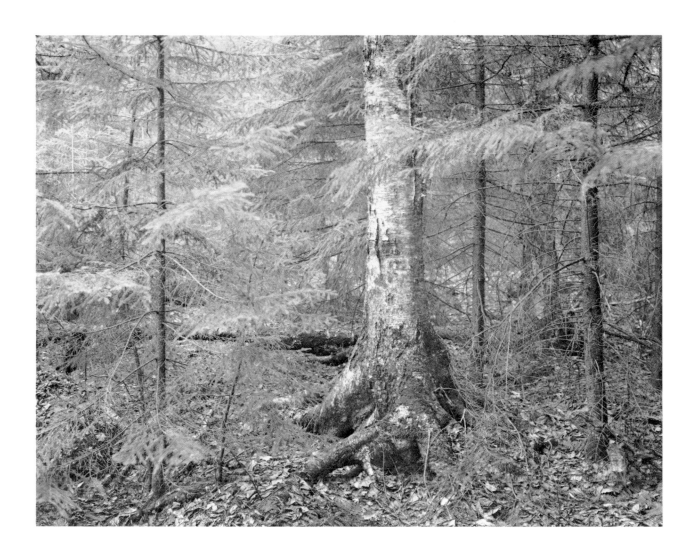

Plate 36. **Steve Szabo,** Adirondacks II, 1978, 19.5x24.5 cm

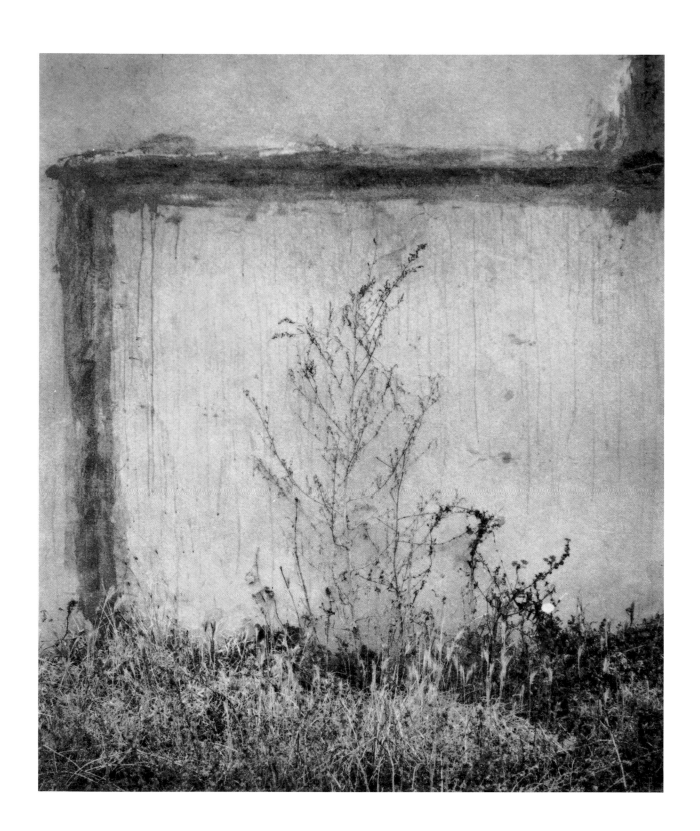

Plate 37. **Joan Myers,** L.A. Landscape VI, Palladium and Pastel, 1978, 26.5x32 cm

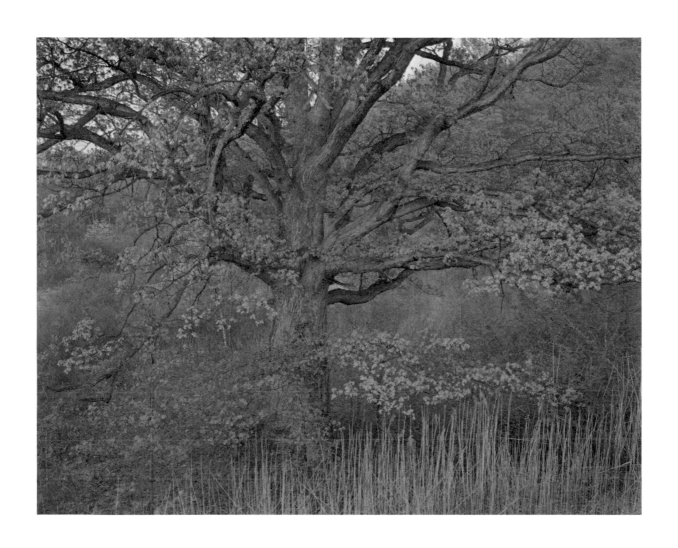

Plate 38. **George A. Tice,** Oak Tree, Holmdel, New Jersey, Palladium Print, 1970, 19.5x24.5 cm

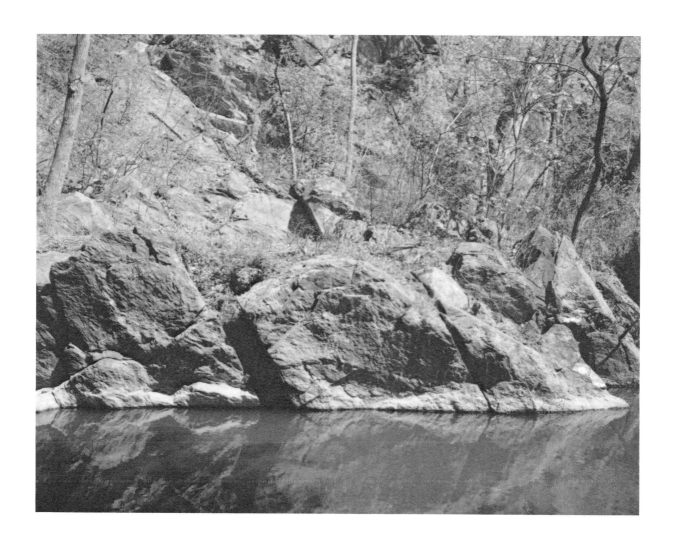

Plate 39. **Tom Schuler,** untitled, 1977, 9.5x12 cm

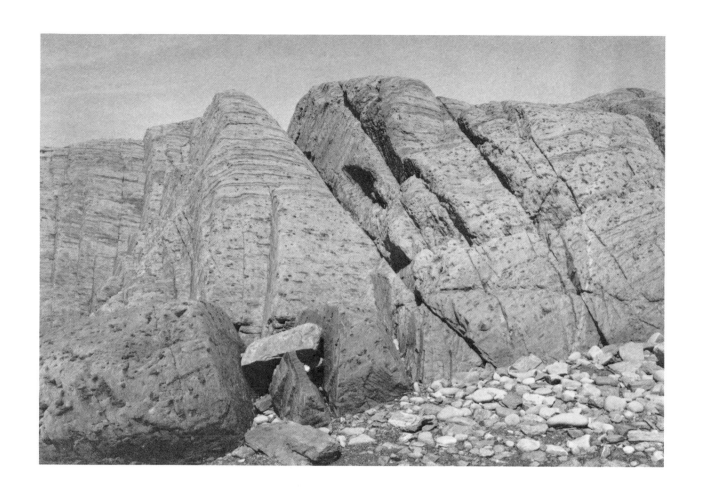

Plate 40. **Geoffrey Ithen,** Rocks, Gaspé, 1975, 12x17 cm

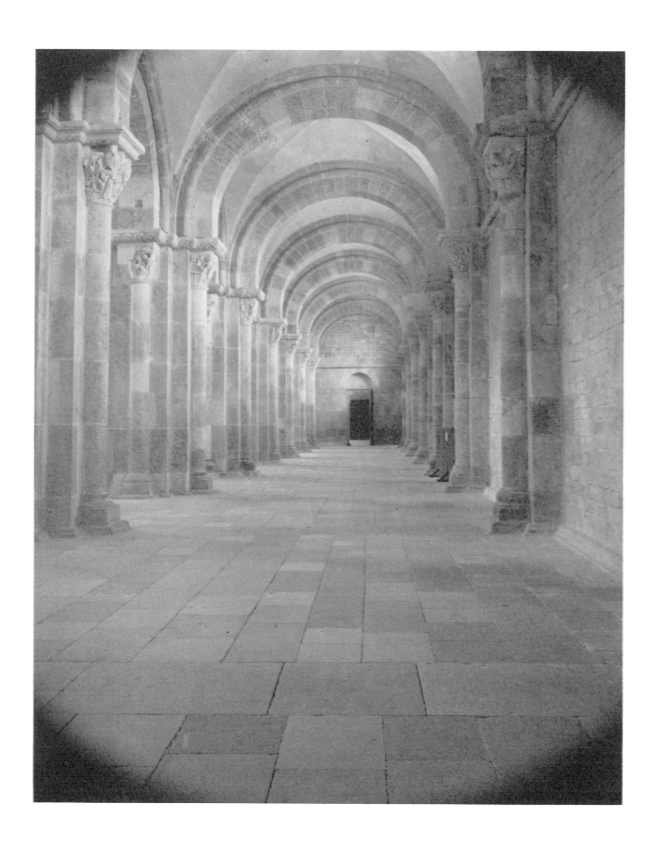

Plate 41. **Tom Shuler,** untitled, 1977, 9.5x12 cm

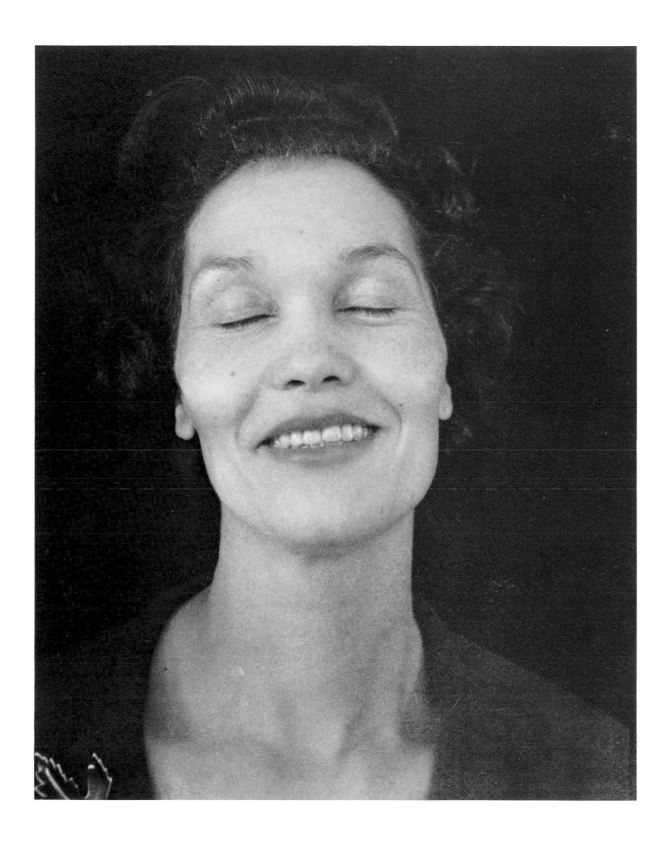

Plate 42. **Nancy Rexroth,** Evelyn Milligan, 1978, 9.5x12 cm

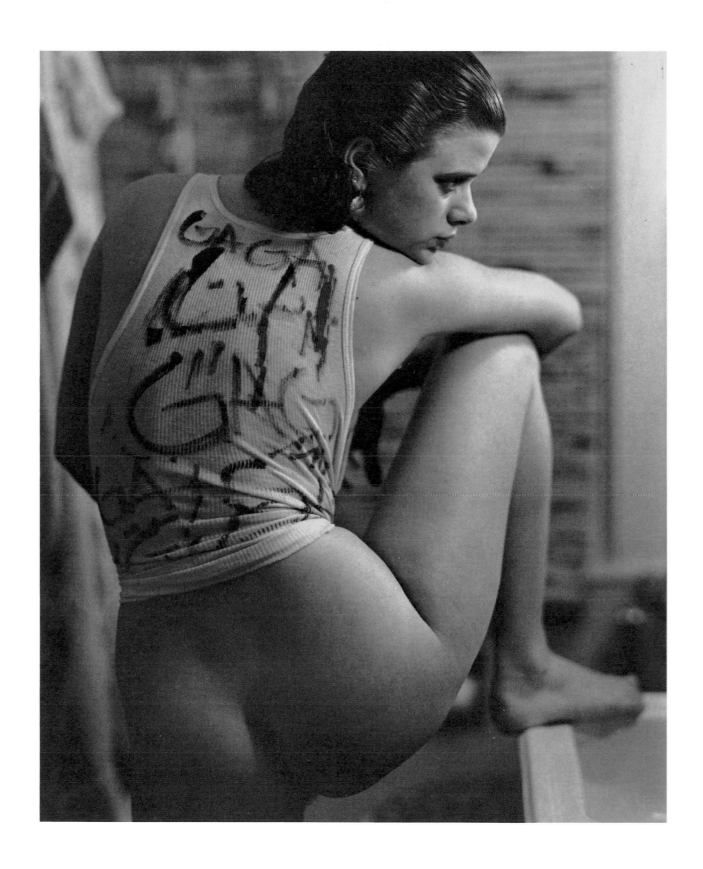

Plate 43. **Tom Shillea,** GaGa, 1978, 19.5x24.5 cm

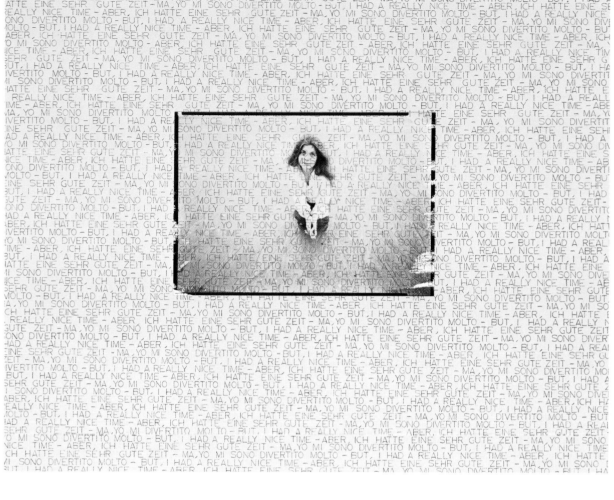

Plate 44. **Klaus Schnitzer/Robert Sennhauser,** Collaboration, 1978, 32.5x40.5 cm

THE
PLATINUM
PRINT

THE

APPENDIX

BIBLIOGRAPHY

Abney, Captain. *Platinotype, Its Preparation and Manipulation.* London: Sampson, Low, Marston, and Company, 1895.

Anderson, Paul L. *The Technique of Pictorial Photography.* Philadelphia: J. B. Lippincott, 1917.

Anderson, Paul L. *Pictorial Photography Its Principles and Practice.* Philadelphia: J. B. Lippincott, 1917.

Anderson, Paul L. *The Fine Art of Photography.* Philadelphia: J. B. Lippincott, 1919.

Bry, Doris. *Alfred Stieglitz: Photographer.* Boston: Museum of Fine Arts, 1965.

Burbank, W. H. *Photographic Printing Methods.* New York: The Scovil & Adams Company, 1891.

Burnett, C. J. *On The Production of Direct Positives — On Printing by the Salts of the Uranic and Ferric Oxides*. London: The Photographic and Fine Art Journal, Vol. XI, No. VII. June 1858

Clark, Lyonel. *Platinum Toning*. New York: The E. and H. T. Anthony Company, 1890.

Dawson, George. *The Platinotype Printing Process*. London: British Journal of Photography, Vol. 27, No. 1029, 1880.

Eder, Josef Maria. *The History of Photography*. New York: The Columbia University Press, 1945.

Emerson, Peter Henry. *Naturalistic Photography for Students of the Art, Including The Death of Naturalistic Photography*. 3rd Edition. New York: The Scovil & Adams Company, 1899.

Evans, Frederick. *Some Notes on Platinotype Printing*. London: The Amateur Photographer, September 8, 1908.

Gassan, Arnold. *Handbook for Contemporary Photography*. 4th Edition. Rochester: Light Impressions Corp., 1977.

Gernsheim, Helmut and Alison, ed. *Alvin Langdon Coburn Photographer, An Autobiography*. London: Farber & Farber. 1966.

Gernsheim, Helmut and Alison. *The History of Photography*. New York: McGraw-Hill Co., 1969.

Gernsheim, Helmut. *Creative Photography*. Bonanza Books, 1962.

Goodman, Alan. *Instruction and Troubleshooting Guide for Platinum and Palladium Photoprinting*. Wilmington: Elegant Images, 1977.

Hafey, John and Shillea, Tom. *Platinotypes*. Rochester: Plata Press, 1978.

Harvith, John and Susan. *Karl Struss: Man with a Camera*. Ann Arbor: Cranbrook Academy of Art, 1976.

Hinton, A. Horsley. *Printing, A Simple Book on the Process*. London: Watson and Vinety Ltd., 1897.

Hoffman, Michael., ed. *Paul Strand, Sixty Years of Photography*. Millerton: Aperture Inc., 1976.

Hunt, Robert. *Researches on Light*. London: Longman, Brown, Green, and Longman, 1844.

Jenkins, Reese V. *Images and Enterprise*. Baltimore: The Johns Hopkins University Press, 1975.

Lietz, Ernst. *Modern Heliographic Processes*. New York: D. Nostrand Company, 1888.

Mason, Robert G., ed. *Life Library of Photography: The Print*. New York: Time-Life Books. 1970.

Mason, Robert G., ed. *Life Library of Photography: Caring for Photographs*. New York: Time-Life Books. 1970.

Newhall, Beaumont. *The History of Photography*. New York: The Museum of Modern Art, 1964.

Newhall, Beaumont. *Frederick Evans*. Millerton: Aperture Inc., 1973.

Newhall, Nancy. *P. H. Emerson, The Fight for Photography as a Fine Art*. Millerton: Aperture Inc., 1975.

Naef, Weston. *The Collection of Alfred Stieglitz*. New York: Viking Press, 1978.

Pizzighelli, Captain, and Hubl, Arthur Baron V. *Platinotype*. London: Harrison and Harrison, 1886.

Rexroth, Nancy L. *The Platinotype 1977*. Yellow Springs: Violet Press, 1977.

Rodger, T. *On Platinotypes*. London: British Journal of Photography, Vol. 24, No. 884. 1877.

Warren, W. J. *The Platinotype Process of Photographic Printing*. London: Iliffe Sons and Sturmey Ltd. n.d.

Willis, William. *Notes on the Platinotype Process*. London: British Journal of Photography, Vol. 26, No. 980. 1879.

Willis, William. *On Some Improvements in Platinotype Printing*. London: British Journal of Photography, Vol. 27, No. 1045. 1880.

Young, James. *The Platinotype Printing Process*. London: British Journal of Photography, Vol. 27, No. 1028. 1880.

NOTES

[1]Captain Abney, *Platinotype, Its Preparation and Manipulation* (London: Sampson, Low, Marston and Co., 1895), p. 2.

[2]Josef Maria Eder, *The History of Photography* (New York: Columbia University Press, 1945), pp. 177-178.

[3]Lyonel Clark, *Platinum Toning* (New York: E. and H. T. Anthony Co., 1890), p. 5.

[4]Robert Hunt, *Researches On Light* (London: Longman, Brown, Green, and Longman, 1854), p. 151.

[5]Abney, *Platinotype*, p. 12.

[6]Hunt, *Researches On Light*, p. 152.

[7]Ibid., p. 153.

[8]Ibid., p. 155.

[9]Abney, *Platinotype*, p. 7.

[10]Ibid., p. 8.

[11]Helmut Gernsheim, *The History of Photography* (New York: McGraw-Hill, 1969), p. 345.

[12]Abney, *Platinotype*, p. 15.

[13]Eder, *History of Photography*, p. 544.

[14]Ironically, George Eastman was employed at the same time by a bank in Rochester, New York.

[15]Eder, *History of Photography*, p. 544.

[16]Abney, *Platinotype*, p. 19.

[17]Eder, *History of Photography*, p. 544. (Patent No. 2800, July 12, 1878)

[18]Ibid., p. 544. (Patent No. 117, March 15, 1880)

[19]Abney, *Platinotype*, p. 21.

[20]Ibid., p. 16.

[21]Eder, *History of Photography*, p. 544.

[22]Ibid., p. 545.

[23]Abney, *Platinotype*, p. 23.

[24]W. J. Warren, *The Platinotype Process of Photographic Printing* (London: Iliffe Sons and Sturmey Ltd., n.d.) p. 26.

[25]Reese V. Jenkins, *Images and Enterprise* (Baltimore: The Johns Hopkins University Press, 1975), p. 205.

[26]Ibid., p. 204.

[27]Correspondence with Eastman Kodak Company.

[28]Nancy Newhall, *P. H. Emerson, The Fight for Photography as a Fine Art* (Millerton: Aperture Inc., 1975), p. 14.

[29]Ibid., p. 17.

[30]Ibid., p. 16.

[31]Ibid., p. 16.

[32]Ibid., p. 18.

[33]Beaumont Newhall, *The History of Photography* (New York: The Museum of Modern Art, 1964), p. 61.

[34]Ibid., p. 61.

[35]Naef, *The Collection of Alfred Stieglitz*, p. 16.

[36]Nancy Newhall, *P. H. Emerson*, p. 3.

[37]Ibid., p. 4.

[38]Ibid., p. 30.

[39]Ibid., p. 34.

[40]Ibid., p. 40.

[41]Helmut Gernsheim, *Creative Photography* (New York: Bonanza Books, 1962), p. 145.

[42]Nancy Newhall, *P. H. Emerson*, p. 42.

[43]Ibid., p. 89

44Peter Henry Emerson, *The Death of Naturalistic Photography* 3rd edition (New York: Scovil & Adams Co., 1899)

45Naef, *The Collection of Alfred Stieglitz*, p. 24.

46Ibid., p. 20.

47Doris Bry, *Alfred Stieglitz: Photographer* (Boston: Museum of Fine Arts, 1965), p. 13.

48Gernsheim, *History of Photography*, p. 469.

49Robert G. Mason, ed., *Life Library of Photography: The Print* (New York: Time-Life Books, 1970), p. 32.

50Ibid., p. 32.

51Bry, *Alfred Stieglitz*, p. 13.

52Beaumont Newhall, *The History of Photography*, p. 117.

53Bry, *Alfred Stieglitz*, p. 13.

54Naef, *The Collection of Alfred Stieglitz*, p. 17.

55Bry, *Alfred Stieglitz*, p. 14.

56Ibid., p. 14.

57Beaumont Newhall, *The History of Photography*, p. 106.

58Bry, *Alfred Stieglitz*, p. 14.

59Ibid., p. 15.

60Ibid., p. 16.

61William Innes Homer, *Symbolism of Light, The Photographs of Clarence H. White* (Wilmington: Delaware Art Museum, 1977), pp. 34-35.

62Naef, *The Collection of Alfred Stieglitz*, p. 153.

63Helmut and Alison Gernsheim, ed., *Alvin Langdon Coburn, Photographer, An Autobiography* (London: Faber & Faber, 1966), p. 18.

64Edward R. Dickinson, ed., *Platinum Print, A Journal of Personal Expression*, Volume 1, No. 7, February 1915.

65Dickinson, *Platinum Print*, Volume 2, No. 1, January 1915.

66Paul L. Anderson, *The Fine Art of Photography* (Philadelphia: J. B. Lippincott, 1919), p. 260.

67Naef, *The Collection of Alfred Stieglitz*, p. 216.

68Beaumont Newhall, *The History of Photography*, p. 117.

69Michael Hoffman, Ed., *Paul Strand, Sixty Years of Photography*, (Millerton: Aperture Inc., 1976), p. 21.

70Ibid., p. 21.

TECHNICAL INFORMATION

This appendix is not intended as a guide to the preparation of platinum paper or its development and fixation, but as a guide to the chemical compositions and proportions of the platinotype process. The bibliography lists numerous technical sources for the preparation and printing of platinum paper.

The Platinum Emulsion

The platinum emulsion is mixed from varying proportions of solutions A, B, and C to match the requirements of a particular negative. The potassium chlorate in Solution B controls the contrast.

Solution A:

Distilled Water	60 ml's
Oxalic Acid	1.1 grams
Ferric Oxalate	16 grams

Solution B:

Distilled Water	60 ml's
Oxalic Acid	1.1 grams
Ferric Oxalate	16 grams
Potassium Chlorate	0.3 grams

Solution C:

Distilled Water	35 ml's
Potassium Chloroplatinite	7 grams

Additives to the platinum emulsion
 (1) Lead Oxalate (cold tone)
 (2) Gold Chloride (warm tone)
 (3) Mercuric Chloride (warm tone)

1. For soft negatives:
 Solution A - 4 drops
 Solution B - 7 drops
 Solution C - 12 drops

2. For average negatives:
 Solution A - 7 drops
 Solution B - 4 drops
 Solution C - 12 drops

3. For contrasty negatives:
 Solution A - 9 drops
 Solution B - 2 drops
 Solution C - 12 drops

The Developer Solutions

(1) Potassium Oxalate (454 grams to 48 ounces of water)
(2) Sodium Acetate
(3) Citrate Developer (Elegant Images)

Additives to the developer solutions
 (1) Mercuric chloride (warm tone)
 (2) Potassium dichromate (increases contrast)
 (3) Glycerine (retards development, used for localized development)

Clearing Baths

(1) Hydrochloric Acid (15ml's to one liter of water)
(2) Citrate Clearing Bath (Elegant Images)